WORTHING

THE POSTCARD COLLECTION

Antony Edmonds

Amberley

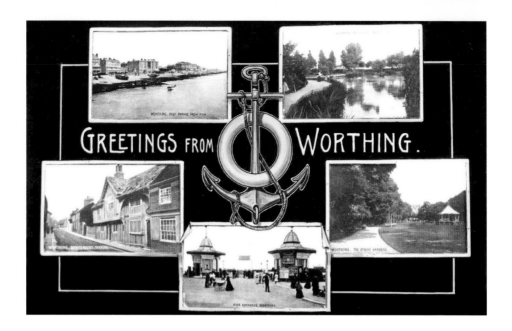

To Joanna

without whose move to Worthing in 2007 the most charming seaside town in Sussex would never have been more to the author than a place on the map

First published 2013

Amberley Publishing
The Hill, Stroud
Gloucestershire, GL5 4EP

www.amberley-books.com

Copyright © Antony Edmonds, 2013

The right of Antony Edmonds to be identified as the Author of this work has been asserted in accordance with the Copyrights, Designs and Patents Act 1988.

ISBN 978 1 4456 1640 7 (PRINT)
ISBN 978 1 4456 1659 9 (EBOOK)

British Library Cataloguing in Publication Data.
A catalogue record for this book is available from the British Library.

Typeset in 9.5pt on 12pt Celeste.
Typesetting by Amberley Publishing.
Printed in the UK.

CONTENTS

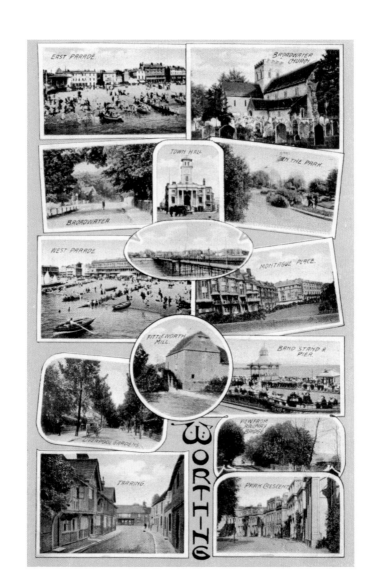

EAST PARADE.

BROADWATER CHURCH.

TOWN HALL.

ON THE PARK.

BROADWATER.

WEST PARADE.

MONTAGUE PLACE.

FITTLEWORTH MILL.

BAND STAND & PIER.

LIVERPOOL GARDENS.

VIEW FROM RAILWAY BRIDGE.

WORTHING

TARRING.

PARK CRESCENT.

INTRODUCTION

THE SELECTION

The decision to confine this selection of old postcards of Worthing to cards from the Edwardian era – together with a few from outside this period that show the town as it was at that time – was an easy one to make, for two reasons.

The first is that during the reign of Edward VII – which lasted from 22 January 1901 until 6 May 1910 – Worthing was in its graceful architectural prime. In 1901 the seafront from Splash Point in the east to Heene Terrace in the west had been fully built for some twenty years; and, with the exception of the arrival of the Dome in 1910–11, it remained almost entirely unaltered for a further quarter of a century.

The second reason that this book chooses to focus on Edwardian Worthing is that the Edwardian Age was the great age of the postcard. Between the death of Queen Victoria and the start of the First World War over ten billion postcards were posted in Britain. But it was not just a question of quantity. The quality and the artistry of Edwardian postcards far exceed those of later periods, especially the dull and cheaply produced sepia views from between the two world wars.

The longest section of this book constitutes a complete photographic record of the Edwardian promenade. The cards are arranged building by building in a strict west-to-east sequence, providing the modern visitor with a detailed guide to the seafront as it was a hundred years ago. Away from the seafront, however, this collection does not set out to be a comprehensive photographic record of the Edwardian town, concentrating instead on the areas that were most frequented by visitors, and indeed by postcard photographers.

Most of the cards reproduced in this book can be dated with confidence to between 1899 and 1912. There are half a dozen from later in the 1910s, and about a dozen from the 1920s, 1930s and, in one case, 1940s. There are, however, only two cards on which any structure appears that was not present during the Edwardian era. The Dome is absent from the book, since its construction did not begin until after the death of Edward VII.

Over a third of the postcards are in colour. Colour photography was in its infancy in the Edwardian age, and too expensive for postcard firms to use. The attractive and characterful colour postcards of the period were produced by tinting monochrome images, using a variety of processes – and with variable results, the shades chosen by the colourists not always being totally true to life.

Two publishers must be named in this introduction, because between them they contribute a third of the cards to this selection. The first is the French firm of Lévy Sons & Co., whose cards are instantly recognisable both from their style and from their captions ending with the letters 'LL'. Most postcard collectors wrongly believe that these letters stood for 'Louis Lévy', but no person of that name was associated with the firm. This error probably originates from confusion with an American called Louis Levy, who helped develop some important early photographic processes. The letters were in fact the first letters of the surnames of the firm's original partners, Isaac Lévy and Moisé Léon, who set up their studio in 1862. When Léon retired in 1874, the firm became Lévy Sons & Co., and after Lévy's own retirement in 1895 his two sons took charge of the firm. There are thirty-three Lévy cards in this selection. Postmark and other evidence has established that photographers working for the Lévy firm visited Worthing three times: first in 1906; secondly in 1910; and thirdly in 1914 or 1915. The Lévy firm allocated each town its own number-sequence, and in the case of Worthing this runs to 99, but the total number of different Lévy images of Worthing is nearer 160, because the firm issued many of its views in two versions that shared the same number (see the examples on pp. 50–51).

At the same time as the Lévy firm was active in Worthing, the gifted Tunbridge Wells photographer Harold Camburn (1876–1956), nineteen of whose cards feature in this book, was producing numerous views of the town he photographed more than any other. Camburn was an exponent of the 'real photograph' printing technique, the cards being printed in relatively small numbers on glossy photographic paper. Camburn's cards – which from 1912 onwards were issued under his 'Wells Series' imprint – are, with their crisp images and neat handwritten captions, as recognisable as the Lévy ones. Like Lévy, Camburn gave each location a separate number-sequence. There are Worthing numbers in the 200s, 300s and 400s, but they are all low numbers and seem to relate to uncompleted sequences, so the total number of Camburn postcards of the Worthing area is probably between 250 and 300. Camburn's earliest views of Worthing – those numbered up to around eighty – were photographed in 1910–12, and most of the Camburn cards in this book are of this period.

WORTHING AND KING EDWARD VII

Edward VII visited Worthing several times towards the end of his reign, driving over from Brighton, where he often stayed. Charles Stamper, who was the king's motor engineer between 1905 and 1910, wrote about some of these visits in a book published in 1913. Although Stamper was always in the king's car in order to be available if mechanical problems arose, he says that he never drove the king, but sat in front beside the driver, who was invariably a police constable.

Stamper gives a detailed account of a visit to Worthing on 12 December 1908. He records that, as they drove along the seafront, the king, noticing that the pier was almost deserted, asked that they stop there. The king and his party paid the tolls in the usual way and walked onto the pier. Only a couple of people had seen the king arrive, but word spread rapidly and soon a large crowd gathered. When the king's friend Arthur Sassoon left the rest of the party at the far end of the pier and returned to the pier gates to ask the gateman to obtain a *Telegraph* and a *Times* for the king, he had to thread his way through a mass of people. By this time a senior policeman had arrived and, at Sassoon's suggestion, he told the toll-keeper not to admit any more people. The crowd outside, however, kept on growing. The gateman seemed incapable of carrying out the request to

buy the two newspapers – Stamper attributed this 'either to the overpowering excitement under which he was labouring, or to his fierce determination not to miss a chance of another glimpse of His Majesty' – so Stamper set off to get them himself. He was easily able to obtain a *Telegraph*, but had to drive to the station for a copy of *The Times*. When he got back, the crowd had become enormous, and he had to fight his way onto the pier. As he passed through the pier gates, he saw the king approaching, accompanied by the senior policeman and a constable, who were trying to keep the people back. A way was cleared, but the crowd closed in behind the king, and two of the party were cut off. After seeing the king into the car, Stamper went back to ask the crowd to let the king's friends through. The party then drove out of Worthing, stopping when they were clear of the town so that the king could stroll on the shore without interruption.

There is a tradition that Edward VII stayed several times at Beach House (pictured on p. 56), as the guest of its owner, Sir Edmund Loder. This tradition derives from an anonymous book about Beach House, published in the Worthing Pageant series in 1947, which states that the king stayed there four times in 1908–10. The book also includes the information that Winifred Loraine – wife of actor-manager Robert Loraine – who knew the house under its next owner, wrote that the king had 'often week-ended there'. There is, however, no reference in the biography of Sir Edmund Loder, published in 1923, three years after his death, either to the king's visits or to their having been friends, and Stamper's book suggests that the king's visits to Beach House merely involved his making use of the gardens on day trips from Brighton, as on this occasion early in 1909:

> On 21 February he [the king] motored to Beach House, Worthing. This stands on the shore of the sea on the skirts and to the east of the town. The owner was away, but he had, I was told, asked to be allowed to place the garden at His Majesty's disposal. This was a very fine one, running right down to the sea, with only a wall between it and the waves, while the privacy it afforded was absolute. His Majesty was very pleased with the pleasaunce [grounds], and we brought him there two or three times.

The king's final visit to Worthing was probably on 14 January 1910, when he drove over from Brighton with his mistress, Alice Keppel (whom Stamper is too discreet to mention in his book, even though she was often with the king on these motor excursions). The January 1910 visit is not referred to by Stamper, but the king made a brief record of it in his diary: 'In the morning walk on the beach near Shoreham. In the afternoon motor to Worthing and walk on the Promenade.'

Edward VII died on 6 May 1910, and fourteen days later thousands of people crammed the streets of Worthing on his account, just as they had crowded the pier a year and a half earlier – but this time to watch the memorial procession for the man who, during his relatively short reign, had become one of the best-loved of all British monarchs.

DATES AND MAPS

Many of the dates given in this book for an event in the life of a building – construction, change of use or demolition – are derived from old directories. These directories seem generally to have appeared in the spring of each year and to have recorded the situation at the start of that year, so any event relating to a building would usually have taken place during the year prior to the directory's publication. The assumption has therefore been made that if, for example, a building

first appears in a directory of 1881, it was built in 1880; and that a building that is first absent in a 1934 directory was demolished in 1933. While this approach provides the likeliest date for the event in question, such dates cannot be guaranteed to be exact – not least for the additional reason that the directories are themselves far from error-free. Where directory and other evidence is contradictory or puzzling, approximations have been given ('about fifty years ago' or 'in the late 1950s').

The maps at the end of the book are included to help the reader identify the locations of the seafront buildings depicted in the second section. Although the maps were published in 1896, they show Marine Parade exactly as it was during the Edwardian era. It should be noted, however, that the Royal Hotel (p. 46) burnt down on 21 May 1901, so was present for only the first few months of Edward VII's reign. Away from the seafront, there is one important difference between the 1896 map and the Edwardian town. This relates to the area just north of Steyne Gardens, where part of Warwick House is shown as still standing. This historic house, built around 1785, was being demolished in 1896, and new – although as yet unnamed – streets are already marked out on its gardens and grounds. However, the housing that was soon to line these streets does not appear on the map, nor obviously does the four-storey block that was built on the former front garden of Warwick House in 1901.

After Marine Parade was renumbered in 1881 – the same numbers apply today – the old names of the seafront terraces gradually fell out of use. However, the terrace names are used in the captions in this book in addition to the Marine Parade numbers, both as convenient points of reference and for the historical record; and the old terrace names have also been used on the maps.

SOURCE OF PICTURES

The photographs on the front and back covers of this book are ink-based photolithographs – colour-tinted versions of monochrome photographs – published in 1905 by the Detroit Publishing Company of Michigan. The original photographs were almost certainly produced by Valentine & Sons of Dundee, since the same photographs are credited to Valentine's when they appear in *The Photographic View Album of Worthing and Neighbourhood*, a large format (11 x 8 inches) book published by Charles E. Thomas of Worthing. The book is undated, but probably came out around 1903, since at least one view dates from no earlier than 1902, and none are much later. Valentine's was a major postcard publisher, and the photographs in Thomas's book were also used on postcards.

All the postcards reproduced in this book are from the author's collection, with the exception of the cards on p. 13 (bottom), p. 15 (top), p. 33 (both), p. 38 (top), p. 41 (top), p. 53 (bottom), p. 74 (top), p. 76 (top), p. 77 (both) and p. 87 (top), which come from the Terry Child postcard collection held by West Sussex County Council Library Service at Worthing Library. A further two images, those on p. 46 (top) and p. 56 (top), form part of the library's collection of miscellaneous photographs and postcards (www.westsussexpast.org.uk). The first of these is the only illustration in this book that is not from a postcard.

SECTION 1

OUTLYING AREAS

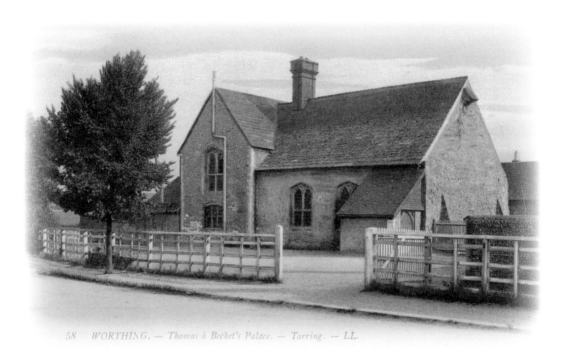

58 *WORTHING. — Thomas à Becket's Palace. — Tarring. — LL.*

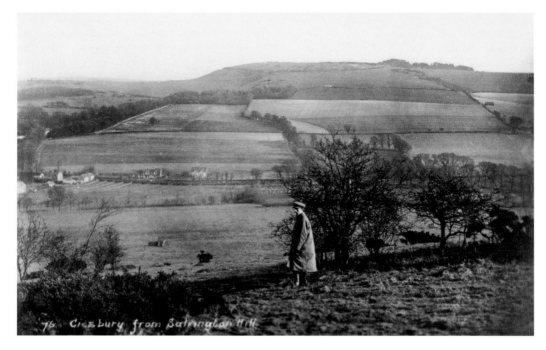

76. Cissbury from Salvington Hill

High Salvington

Our tour of Edwardian Worthing starts at High Salvington – three miles north of the seafront – looking towards the ancient hill forts of Cissbury and Chanctonbury. These two postcards are of particular interest because they are the best surviving photographs that feature Harold Camburn, nineteen of whose cards appear in this selection. He took the photographs himself, probably in 1910, using a delayed-action shutter release.

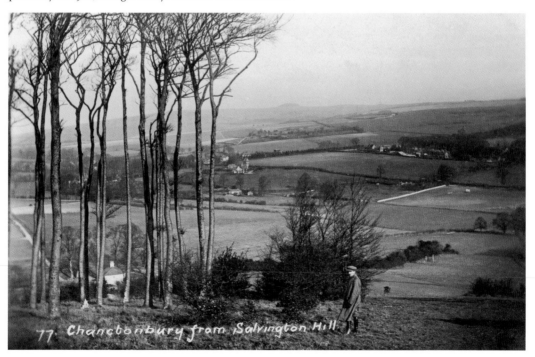

77. Chanctonbury from Salvington Hill

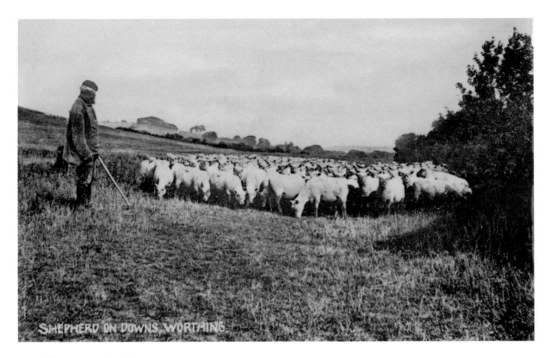

Sheep on the Downs

Most early colour postcards were tinted versions of monochrome photographs, like the card above, but a few publishers produced postcards from paintings. The most prolific painter for postcards was A. R. Quinton, who copied his scenes from photographs, often using considerable artistic licence. The example below, from *c.* 1920, shows the view a few yards east of Salvington Mill. Today, it is largely obscured by trees and houses.

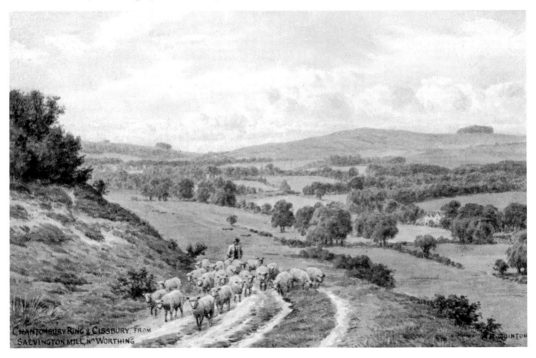

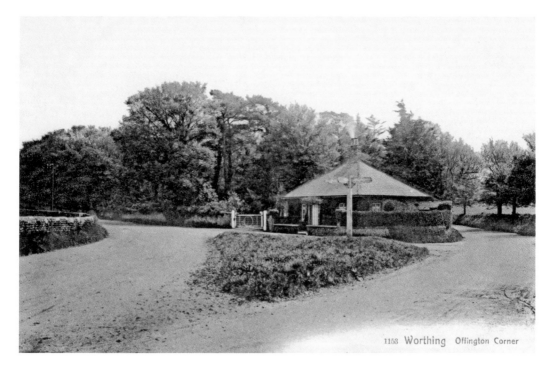

1168 Worthing Offington Corner

The Lodges at Offington

There had been a great house on the historic Offington estate, north-west of Broadwater, since 1357 or earlier, the final house on the site being demolished in 1963. The single-storey lodge, above, was at Offington Corner, at the north-west corner of the estate, while the more frequently photographed two-storey lodge, below, was situated at the north end of Broadwater Green, towards the south-east boundary of Offington Park.

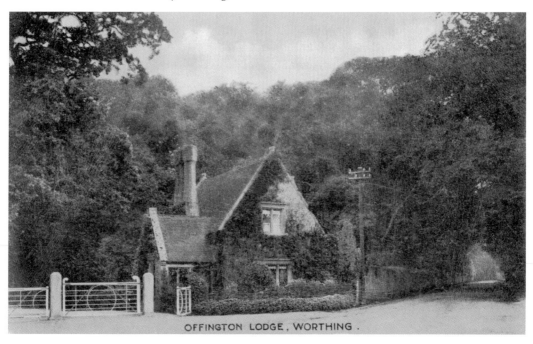

OFFINGTON LODGE, WORTHING.

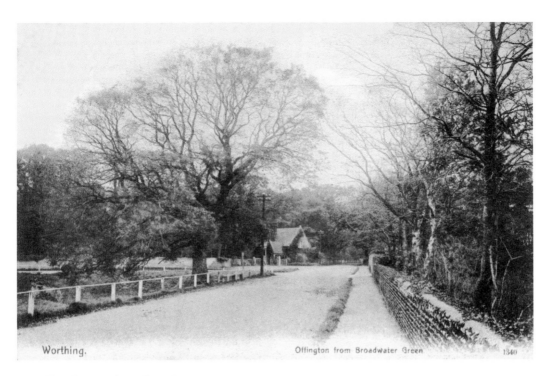

Worthing. Offington from Broadwater Green 1340

The Approach to Broadwater

The photograph above, looking north towards Offington Lodge from Broadwater Street West, shows where the lodge stood in relation to Broadwater Green. About a quarter of a mile south of the lodge was Broadwater's Primary Elementary School, seen on the right of the picture below. It was built in 1873 and demolished in 1937. The Parish Room of 1899 (today the Parish Rooms), left, is still in use. The pair of semi-detached houses beyond it also survives.

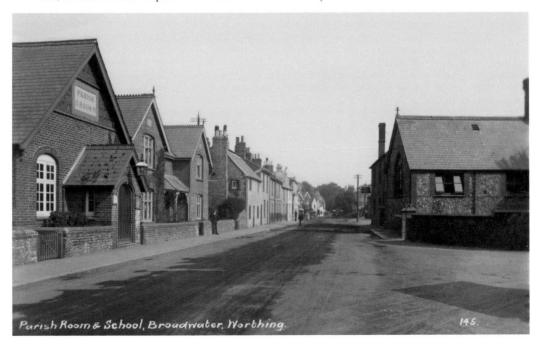

Parish Room & School, Broadwater, Worthing. 145.

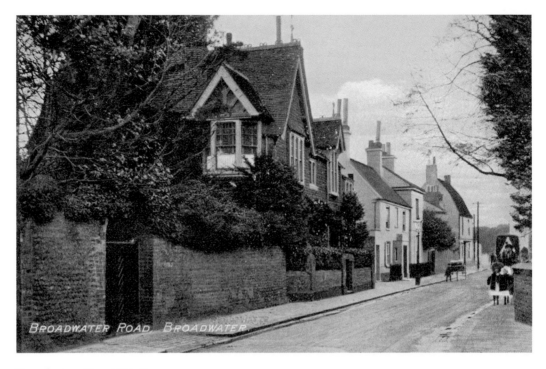

Broadwater Street West

These two postcards are of the same stretch of Broadwater Street West, just north of St Mary's church. The colour view looks northwards towards Broadwater Green, while the monochrome view looks southwards towards Broadwater Cross and the churchyard. The house on the left of the colour picture can be seen at centre-right on the monochrome postcard. None of the buildings seen here survived twentieth-century redevelopment.

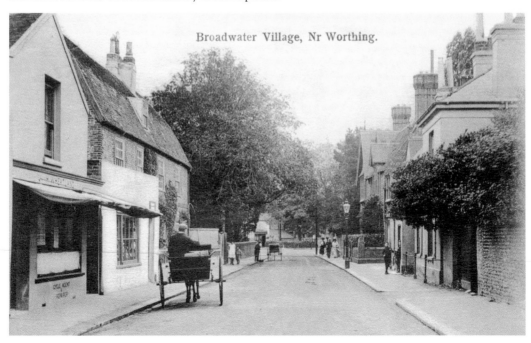

Broadwater Village, Nr Worthing.

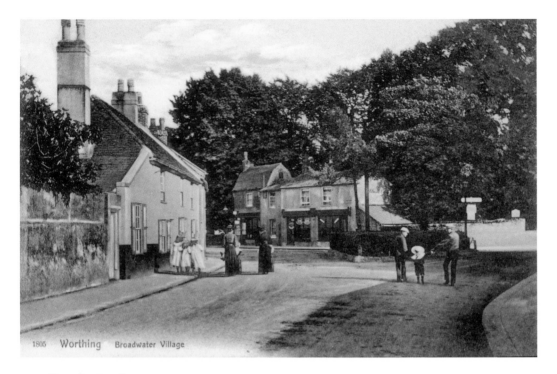

1805 Worthing Broadwater Village

Broadwater Cross

The buildings in the centre of these views of Broadwater Cross survive, but the white house on the left does not. Broadwater retained jurisdiction over the hamlet of Worthing until 1803, while St Mary's Broadwater remained the church that served the people of Worthing until the Chapel of Ease – later St Paul's – opened in 1812. St Mary's was the church that Jane Austen attended during her stay in Worthing in late 1805.

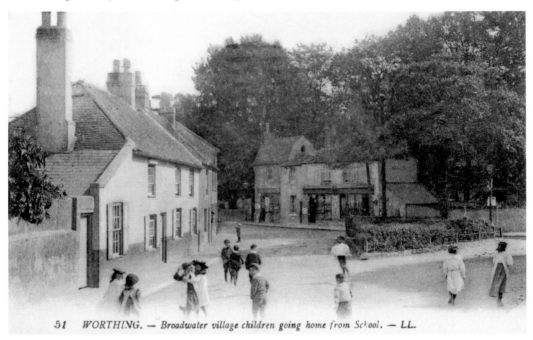

51 WORTHING. — *Broadwater village children going home from School.* — LL.

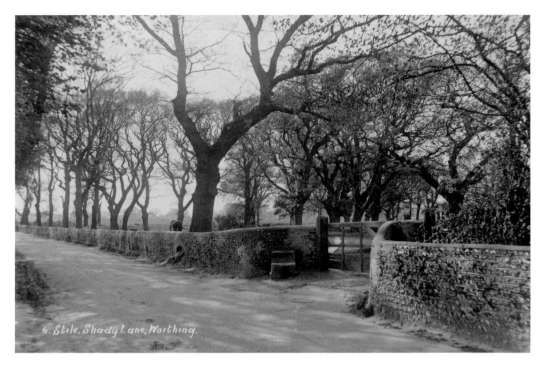

6. Stile, Shady Lane, Worthing.

Shady Lane and the Littlehampton Road

These two locations on the edge of Worthing are unrecognisable today. Both views are west-facing. Shady Lane, above, was the road running west from the north of Broadwater Green, and is now known as Poulter's Lane. The open spaces of Offington Park, seen on the right, are now housing. The junction depicted on the card below is today the roundabout where Yeoman Road joins the A2032. The road to the left is Palatine Road.

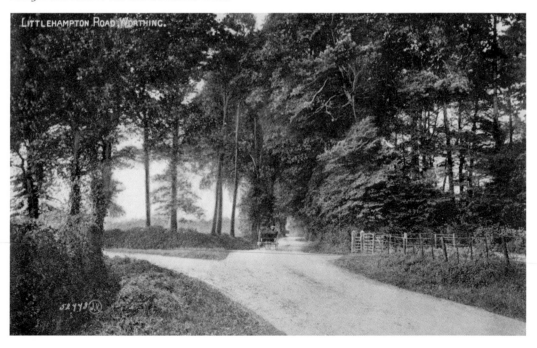

LITTLEHAMPTON ROAD, WORTHING.

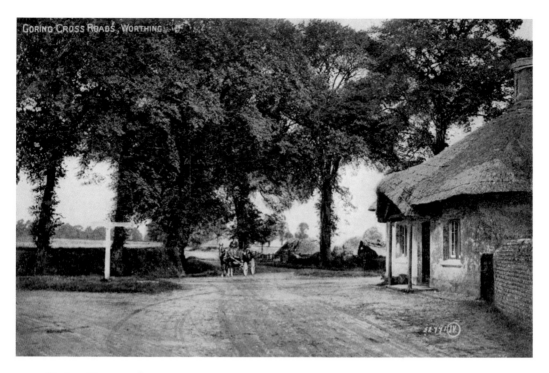

Goring Crossroads

A hundred and fifty yards to the west of the junction seen at the bottom of the facing page was Goring crossroads, today a major roundabout. In the view above, the road straight ahead, Titnore Lane, is now the A2700, and the road to the left is the A259 to Littlehampton. In the view below we are looking eastward towards Broadwater, up what is now the A2032, with the A259 to Goring on the right. The toll-house is long gone.

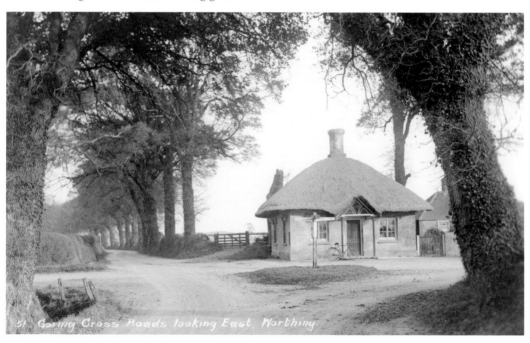

51. Goring Cross Roads looking East, Worthing.

17

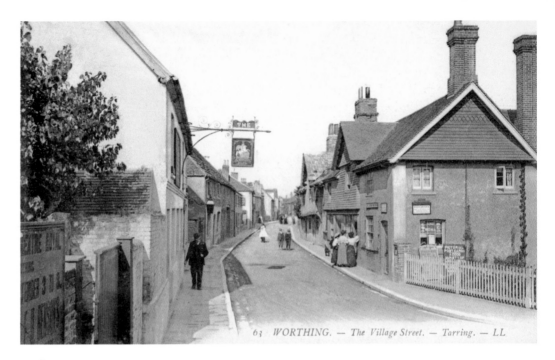

63 WORTHING. — *The Village Street.* — *Tarring.* — LL

High Street, West Tarring

The manor of Tarring was owned by the Canterbury archdiocese from the tenth to the sixteenth centuries, and archbishops travelling through Sussex in the early Middle Ages sometimes stayed in an earlier building on the site of the Old Palace. In spite of a strong tradition linking Thomas à Becket with Tarring, there is no evidence that he ever visited. The timber-framed cottages, at centre above and right below, date from the fifteenth century.

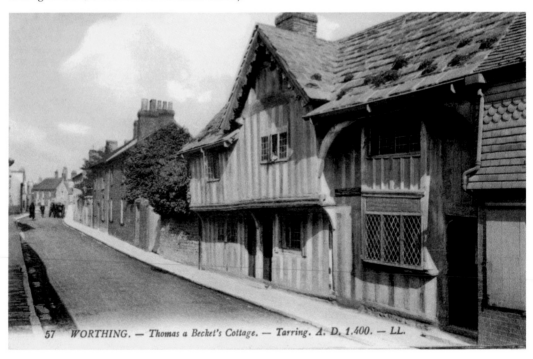

57 WORTHING. — *Thomas a Becket's Cottage.* — *Tarring. A. D. 1.400.* — LL.

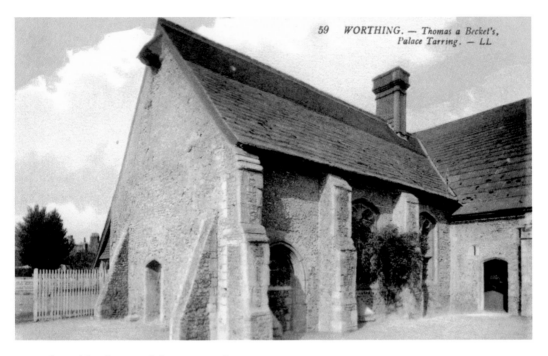

The Old Palace and the Fig Gardens

The Old Palace, above, parts of which date from the thirteenth century, was Tarring's manor house until *c.* 1770, and was then used mainly as a school for 200 years or so. The fig orchard, below, was planted in 1745, and by 1830 there were about a hundred trees, producing 2,000 figs every year. The house remains, but most of the fig trees were cut down when the site was developed for housing a quarter of a century ago.

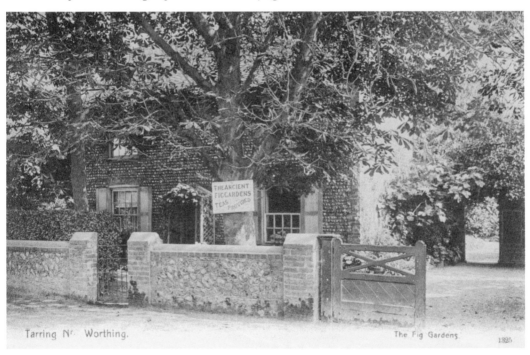

Tarring Nr Worthing. The Fig Gardens

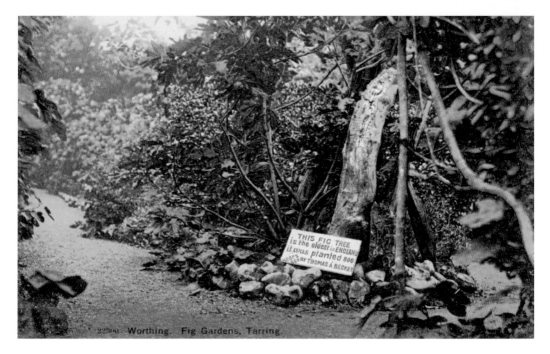

Worthing. Fig Gardens, Tarring.

Thomas à Becket's Fig Tree

There is an implausible tradition that, as the plaques visible on these two cards indicate, Thomas à Becket planted the first tree in the fig gardens. The tree identified as his tree in the picture above, c. 1905, is clearly a different tree from the one in the picture below from c. 1920. The old tree had presumably collapsed in the meantime, and the owners of the garden, reluctant to abandon the tradition, had allocated Becket another tree.

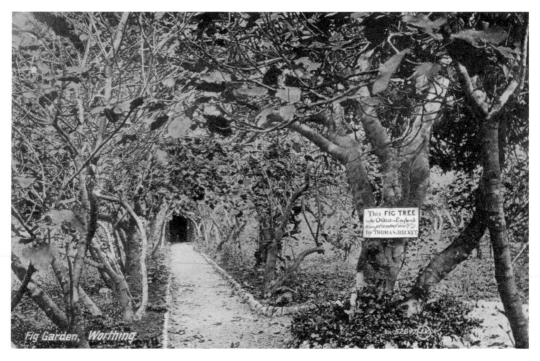

Fig Garden, Worthing.

SECTION 2

ALONG THE
SEAFRONT

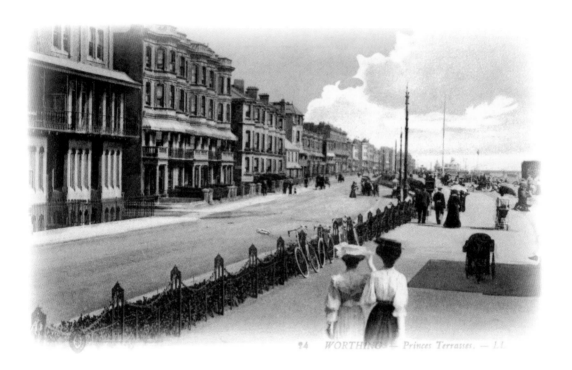

94 WORTHING — Princes Terrasses. — J.L.

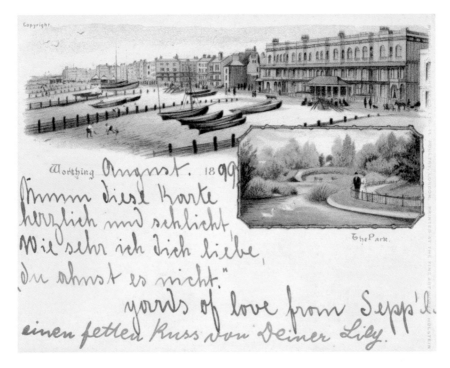

Copyright.

Worthing **August. 18 99**

"Jmmm diese Karte
herzlich und schlicht,
Wie sehr ich dich liebe,
Du ahnst es nicht."

yours of love from Sepp'l.
einen fetten Kuss von Deiner Lily.

The Park.

Early Postcards

Before we start our west-to-east journey along the seafront, here are four early postcards of the 'undivided back' type. The first picture postcards (1895–99) had been court-size cards (4½ x 3½ inches) like the one above. The new standard-size postcards (5½ x 3½ inches) first appeared in 1899, but the backs remained reserved for the recipient's name and address. The message had to be written on the white space provided on the front.

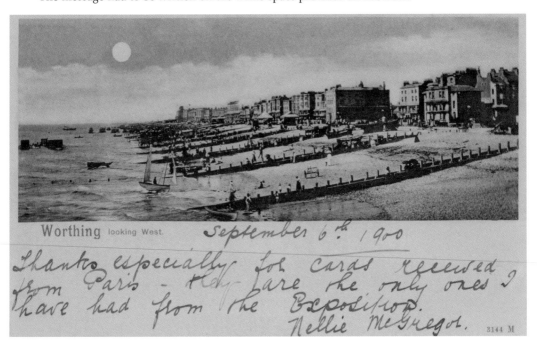

Worthing looking West. September 6th 1900

Thanks especially for cards received from Paris – they are the only ones I have had from the Exposition.
Nellie McGregor.

3144 M

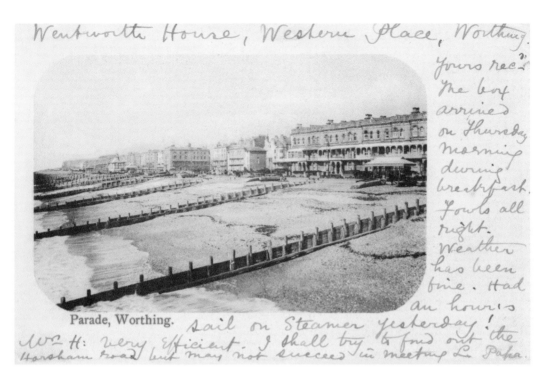

Wentworth House, Western Place, Worthing.

Yours recᵈ The boy arrived on Thursday morning during breakfast. Fowls all right. Weather has been fine. Had an hour's

Parade, Worthing. sail on Steamer yesterday!

Wᵐ H: very Efficient. I shall try to find out the Horsham Road but may not succeed in meeting L Papa.

Divided Backs

When the first cards with divided backs appeared in 1902, it was permissible to write messages on the backs of cards if they were being sent to inland addresses, but not if they were going abroad. Foreign countries were gradually added, and by early 1906 senders could write on the backs of cards destined for all countries except Japan, Spain and the United States. Later that year the embargo on messages on the back was totally removed.

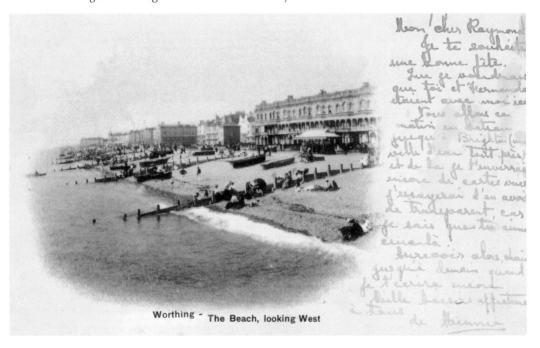

Worthing - The Beach, looking West

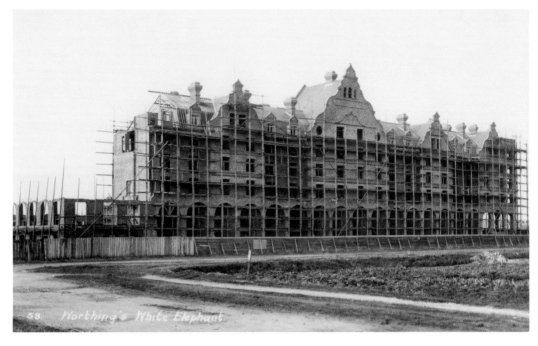

Worthing's White Elephant

In the Edwardian era the shell of the unfinished Metropole Hotel, built in the late 1890s, was the only structure to the west of Heene Terrace. The hotel was to be part of a major new development at West Worthing, including a pier, but the project fell through. The building was completed in 1923 as a block of flats known for many years as The Towers, but today called Dolphin Lodge. The scaffolding remained on the building until at least 1910.

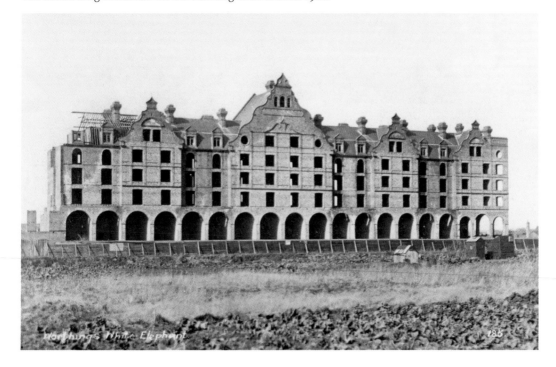

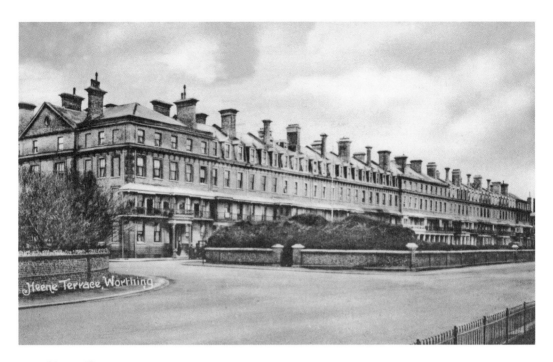

Heene Terrace

Heene Terrace, a third of a mile to the east of the unfinished Metropole, was built in 1865 by the architect G. A. Dean as part of the small separate town of West Worthing. The terrace comprised eighteen terraced houses, with two large 'mansions' at the ends – West Mansions and East Mansions – with entrances on Heene Road and Wordsworth Road respectively. The original twenty houses today contain over 150 flats.

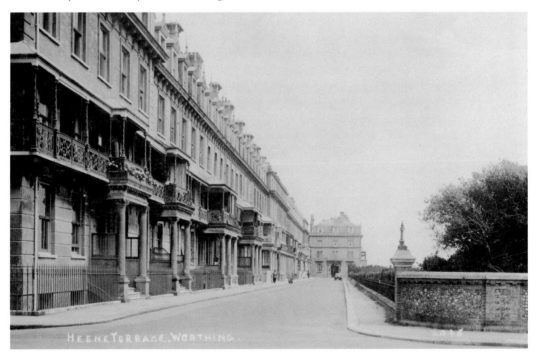

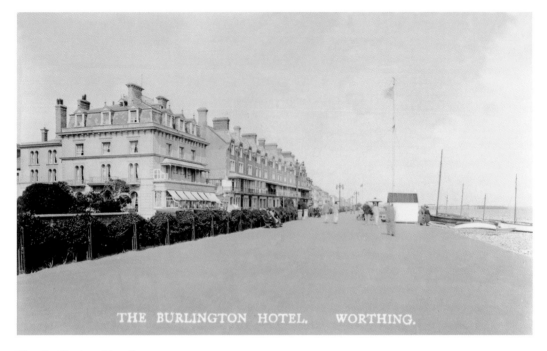

THE BURLINGTON HOTEL. WORTHING.

The Burlington Hotel

The Burlington Hotel, built, like Heene Terrace, in 1864–65 by G. A. Dean, was originally known as the Heene Hotel and subsequently as the West Worthing Hotel, becoming the Burlington in 1890. It is the oldest hotel in Worthing that survives within its original structure, since the earlier Steyne Hotel (p. 52) now forms part of the Chatsworth Hotel. The postcards on this page were produced by the hotel for its guests in the early 1920s.

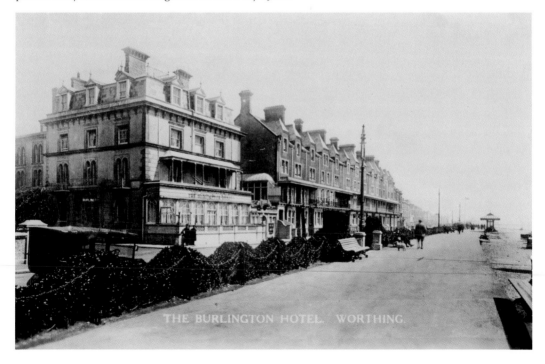

THE BURLINGTON HOTEL. WORTHING.

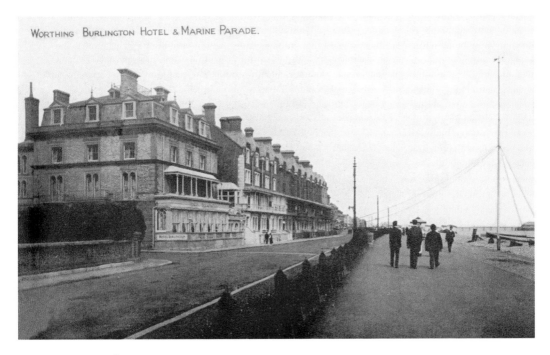

Heene Parade

To the east of the Burlington Hotel was Heene Parade, a terrace of eight houses built in 1867 by the Thorn brothers, Peter and Alexander, who also built the swimming baths at the south-eastern end of Heene Road, demolished in 1973, as well as Thorn's Terrace, which housed their workmen. Thorn's Terrace still stands on the western side of Thorn Road. The brothers also built Blackfriars Bridge and Ennismore Gardens in London.

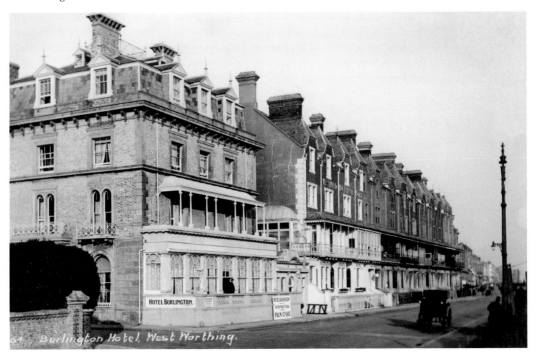

27

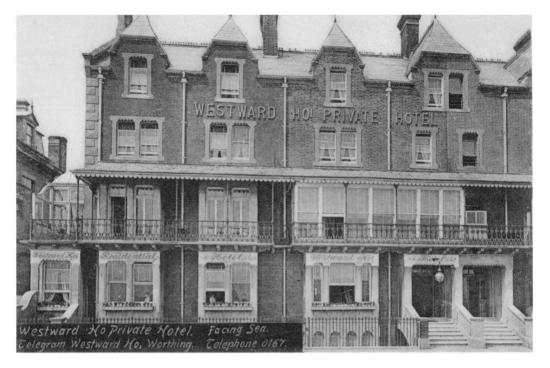

Westward Ho Private Hotel. Facing Sea.
Telegram Westward Ho, Worthing. Telephone 0167.

The Westward Ho Hotel

In 1901 the Westward Ho Private Hotel occupied just No. 8, the house at the western end of Heene Parade, but in 1903 it took over No. 7 as well. The Misses Carr, who ran a girls' school called Seabury at No. 2, were similarly expansionist, adding No. 1 in 1918. The famous suffragette Emily Davison, who died after throwing herself in front of King George V's horse at the 1913 Derby, taught at Seabury School from 1896 to 1898.

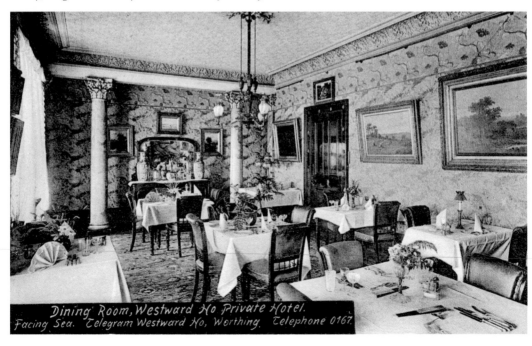

Dining Room, Westward Ho Private Hotel.
Facing Sea. Telegram Westward Ho, Worthing. Telephone 0167.

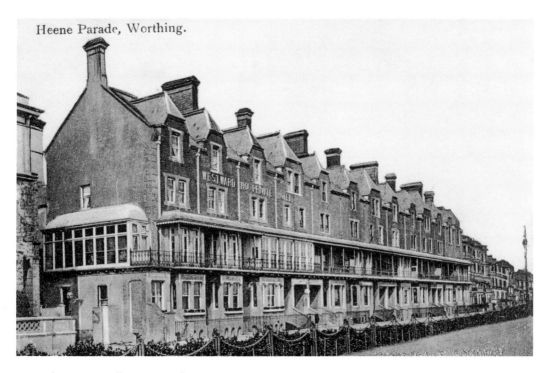

Heene Parade, Worthing.

The Prince Albert Convalescent Home

In 1920 the Westward Ho Hotel, above, was acquired by the Grange Convalescent Home, which had occupied No. 6 Heene Parade since 1914. The enlarged establishment, below, was named the Prince Albert Convalescent Home in honour of George V's second son, later George VI. The Beach Hotel opened at No. 4 in 1914, and by 1934 had acquired the whole terrace, which it transformed into a ninety-four-bedroom art deco hotel, demolished in 2012.

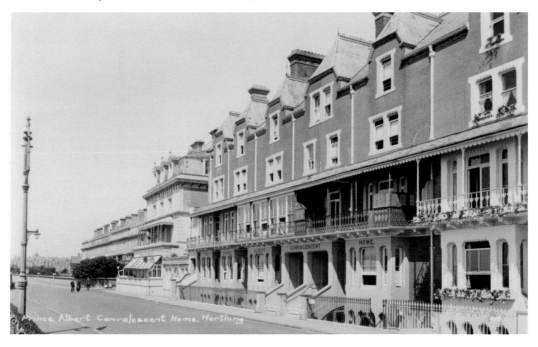

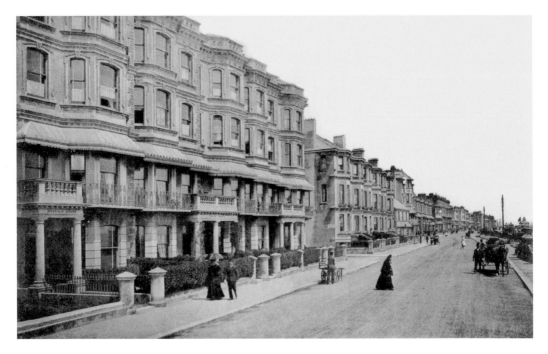

Prince's Terrace

Marine Parade officially began at Thorn Road, so the houses of Prince's Terrace, between Thorn Road and Queen's Road, were the furthest west with Marine Parade addresses (Nos 121–117). In the Edwardian era many of the houses on the seafront had names as well as numbers. The house at the western end of Prince's Terrace was Norfolk House, the middle house Chaddleworth, and the house at the eastern end Untata. Prince's Terrace survives.

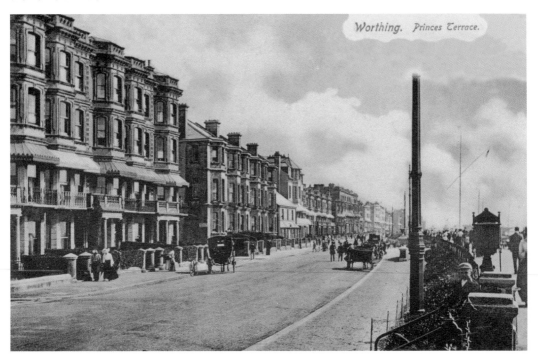

Worthing. Princes Terrace.

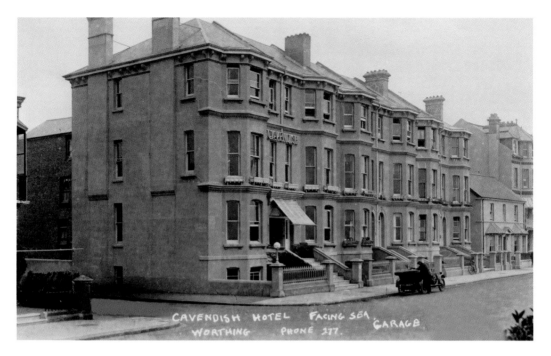

Victoria Terrace

Victoria Terrace – Nos 116–111 Marine Parade, just east of Queen's Road – still stands. The Cavendish Hotel, above, opened in 1920, and the vintage of the car parked at centre-right suggests that the card, with its very amateurish caption, was produced for the hotel's guests at around the same time. The hotel closed in 2012. The Edwardian postcard, below, makes up in atmosphere for what it lacks in crispness.

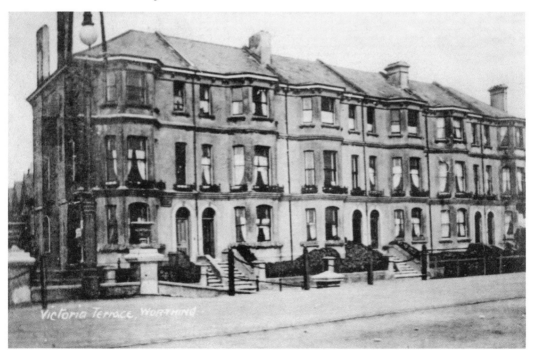

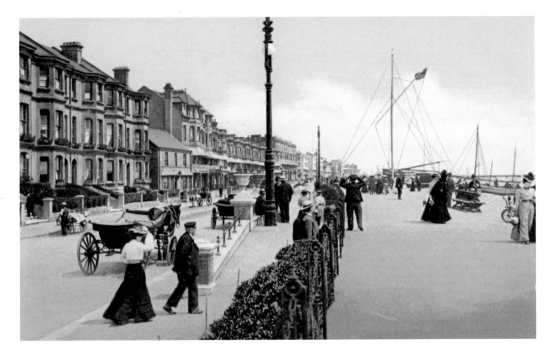

The Coastguard House

A narrow lane separates the eastern end of Victoria Terrace from the old Coastguard House at No. 110 Marine Parade, which is followed by Nos 109–107, originally St James's Terrace and today Claydon Court. Next comes the – unnumbered – Lifeboat House, set back out of sight, and then Nos 106–104 Marine Parade, separated by Western Place from Nos 103–96. All these buildings survive, although some of them are much altered.

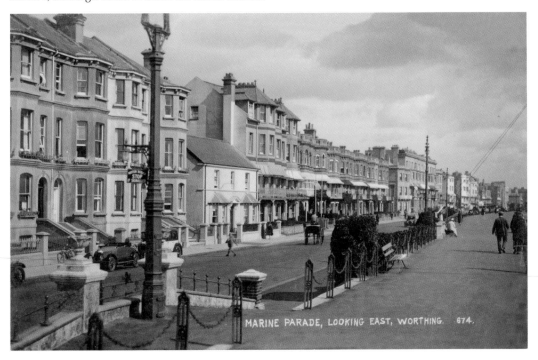

MARINE PARADE, LOOKING EAST, WORTHING. 674.

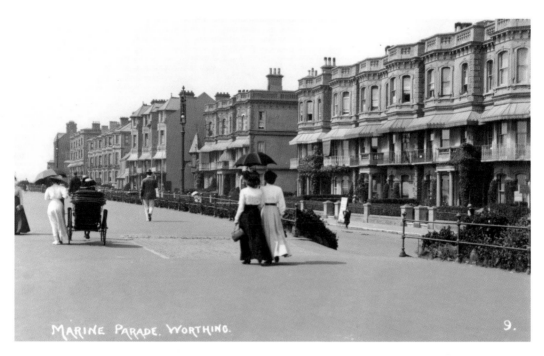

Imperial Terrace

The terrace in the foreground of these cards, Nos 103–96 Marine Parade, between Western Place and West Street, was originally known as Imperial Terrace. It was built in 1880 and still stands today. The Lifeboat House can be glimpsed at centre-left of the card above. The large three-storey house at right of centre below, No. 95 Marine Parade, just east of West Street, later became the Whitehall Private Hotel and is now part of the Travelodge Hotel.

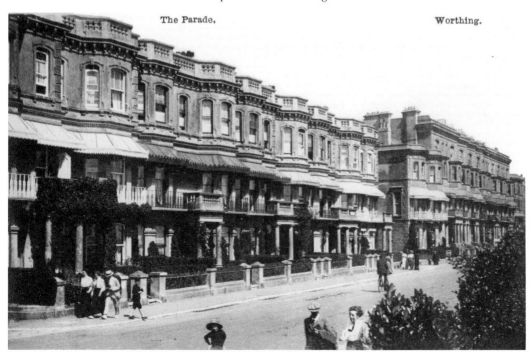

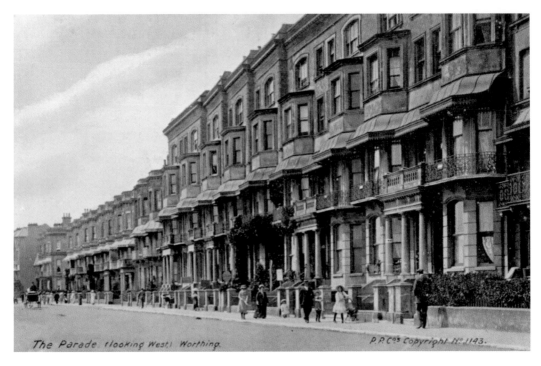

The Parade. (looking West) Worthing. P.P.C⁰ˢ Copyright Nᵒ.1143.

Nos 94–86 Marine Parade

The tall four-storey terrace in these views is now the central section of the Travelodge Hotel (previously the Berkeley Hotel). Originally consisting of nine houses, Nos 94–86 Marine Parade, this was one of the most imposing terraces on the Edwardian seafront, but its façade has been considerably altered over the years. The 'Ladies Bathing' advertised on the card below would have been in the bathing machines, whose function was to preserve modesty.

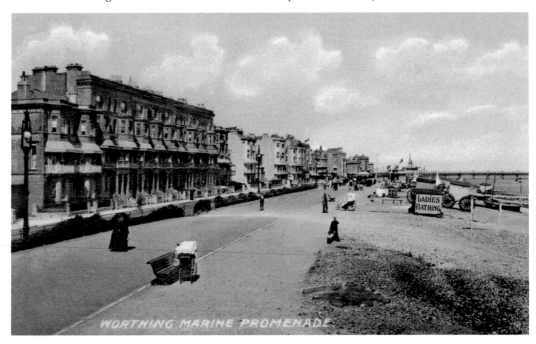

WORTHING MARINE PROMENADE.

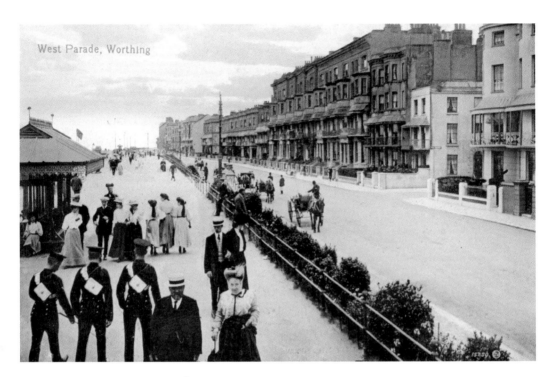

Nos 85–81 Marine Parade

The two houses at Nos 85–84 Marine Parade, right of centre on these cards, and lower than Nos 94–86, now form the eastern end of the Travelodge Hotel. The three-storey house to their right, No. 83 Marine Parade, also survives. The street to its east is West Buildings. The houses on the right of these cards are Nos 82–81 Marine Parade, which were damaged during the Second World War and later demolished to accommodate the Parade Wine Lodge, which opened in 1950.

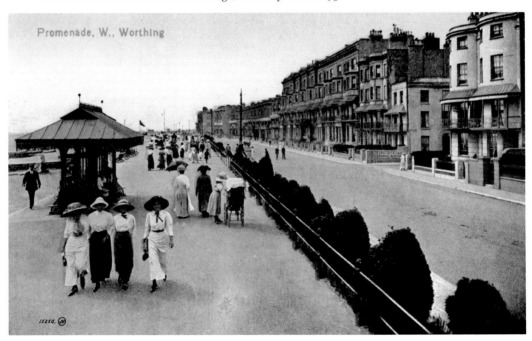

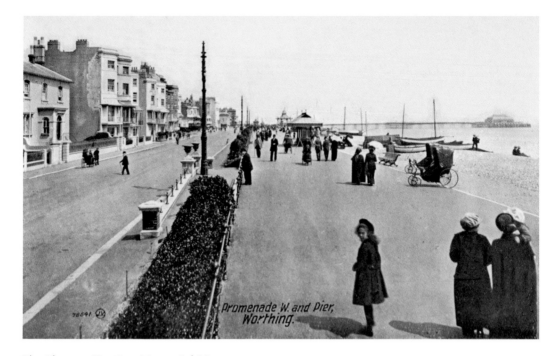

Promenade W. and Pier,
Worthing.

The Thomas Banting Memorial Home

The Thomas Banting Memorial Home, No. 80 Marine Parade, above left, closed in 1946 and was converted into the Parade Wine Lodge, which also extended west over the site of Nos 82–81. Since 2003 the site of Nos 82–80 has been occupied by the magnificent Nautilus block, which closely imitates the old houses at Nos 79–77 Marine Parade and those that used to stand at Nos 82–81. New Street follows. The view below starts at Nos 78–77 Marine Parade.

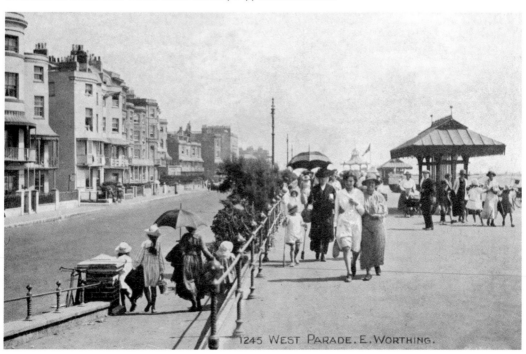

1245 WEST PARADE. E. WORTHING.

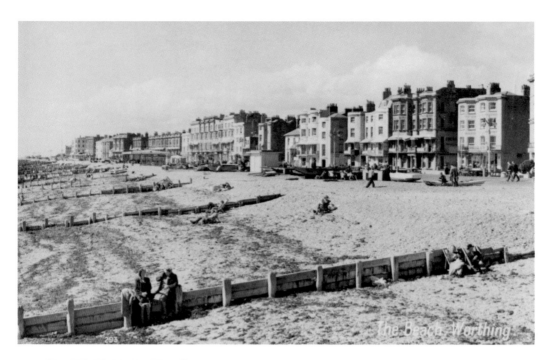

Nos 76–70 Marine Parade

This 1930s view is invaluable because it shows the entire seafront between Prospect Place and the Burlington Hotel exactly as it was in the Edwardian era, except that the art deco Beach Hotel is just visible in the far distance. The card below shows the eastern section of the same view, left to right: New Street; No. 76 Marine Parade (Anglesea House); No. 75 (Beamish House); Nos 74–72; No. 71 (Camden House); No. 70 (Windsor House); Prospect Place.

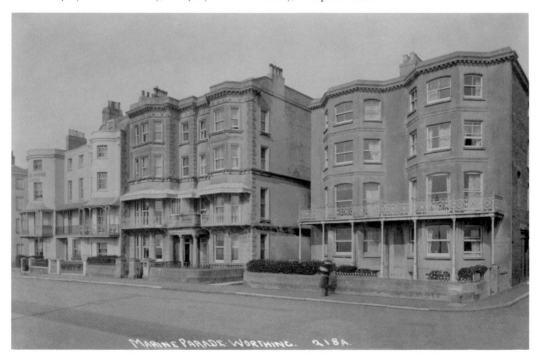

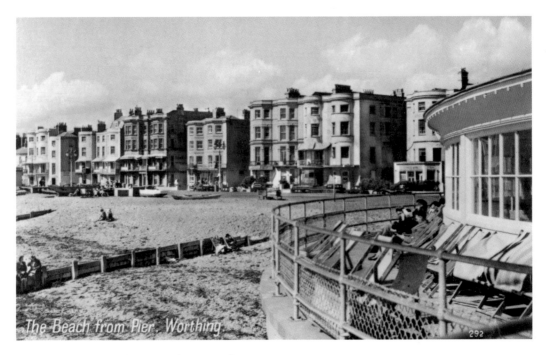

The Beach from Pier, Worthing

Augusta Terrace and the Stanhoe Hotel

The card above, which dates from *c.* 1930 – the 'mini-pier' was built at the same time as the new bandstand in 1925–26 – is included because it shows, at centre-right, Augusta Terrace, Nos 69–66 Marine Parade, which stood between Prospect Place and Augusta Place. On the card below, Augusta Place is followed by the Stanhoe Hotel (which was the surviving western remnant of Augusta House, formerly Trafalgar House, built *c.* 1805), and Nos 63–62 Marine Parade.

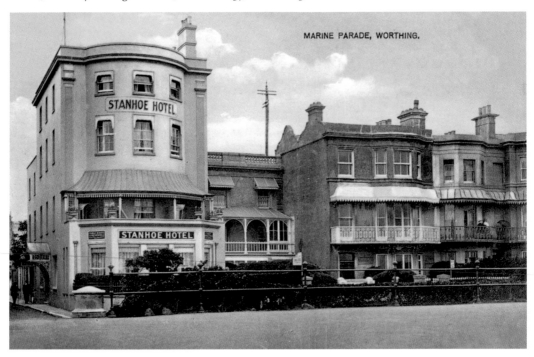

MARINE PARADE, WORTHING.

STANHOE HOTEL

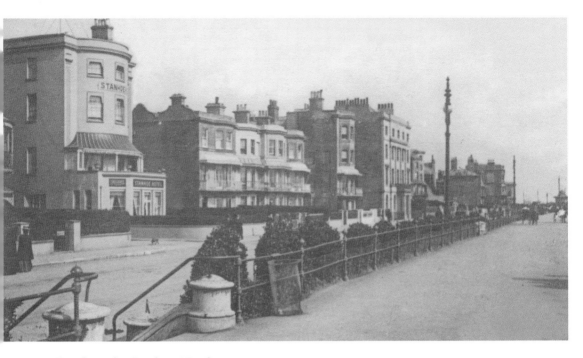

East from the Stanhoe Hotel

The view above shows, left to right: Stanhoe Hotel; Nos 63–59 Marine Parade; Paragon Street; Marlborough House. On the 1920 aerial card below are, left to right: Nos 62–59 Marine Parade; Paragon Street; Marlborough House; Grafton House (behind the double lawn); Montague Cottage (behind narrow lawn); Nos 49–48 Marine Parade; Portland Road; Nos 47–45 Marine Parade; passage to Montague Street. None of these buildings survive, most having been demolished in the 1940s.

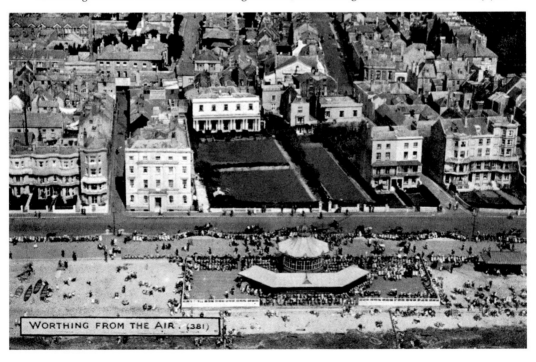

WORTHING FROM THE AIR. (381)

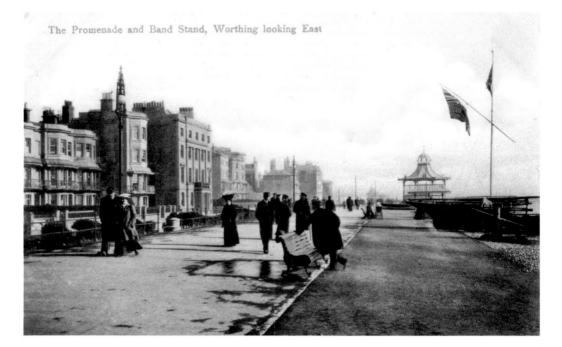

Marlborough House

The fine Regency building at left of centre in the view above, and at far right in the view below, is Marlborough House, which was originally the Royal Baths – part baths, part hotel – built in 1818 by Thomas Trotter, the actor-manager and entrepreneur who ran Worthing's first theatre. It was demolished in 1940. The four-storey house to its west, No. 59 Marine Parade, which in 1910 was known as Hollywood, consisted of apartments.

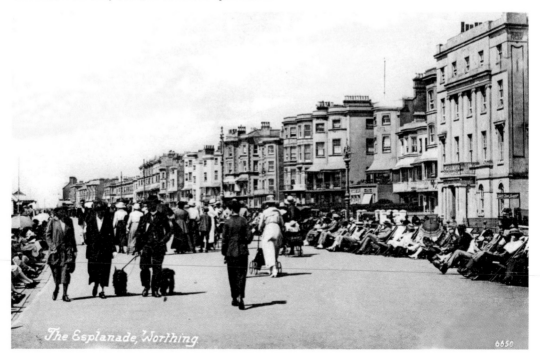

The Esplanade, Worthing

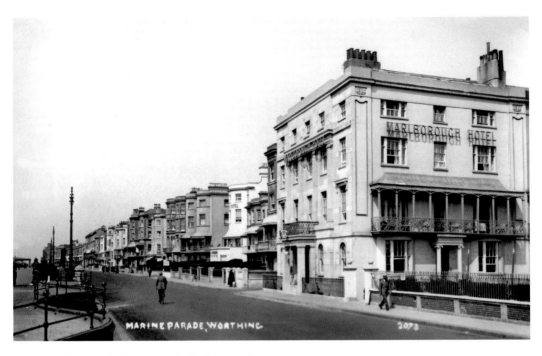

Marlborough House and Marlborough Terrace

On the right of the view above, *c.* 1930, can be seen the entrances to what at the start of the century were originally two separate boarding houses – Marlborough House (No. 58 Marine Parade, seafront entrance) and Argyle House (No. 57, side entrance) – but by 1906 were a single establishment run by the Misses Powis. The part of the building to the north of No. 57 consisted of two houses known as Nos 2–3 Marlborough Terrace, visible on the right of the card below.

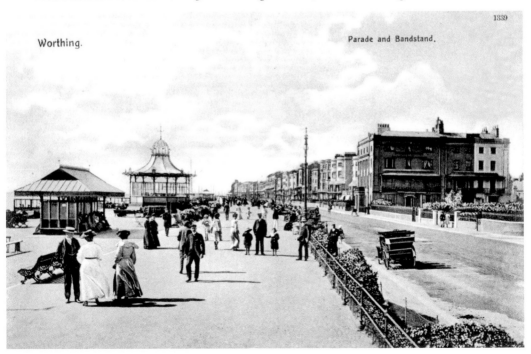

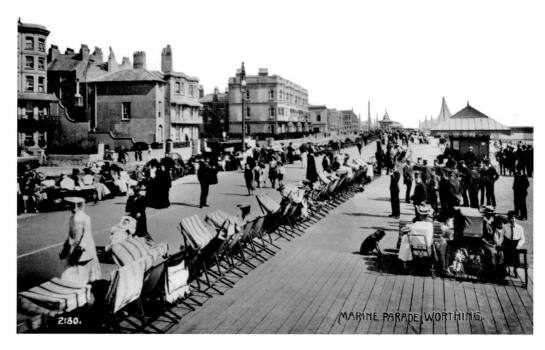

The Montpelier Houses

The card above shows, from left to centre: No. 45 Marine Parade; the Montpelier Houses (Nos 44–43 Marine Parade); Montague Place; Cambridge Terrace (Nos 42–36 Marine Parade). In the view below, the Montpelier Houses, which dated from *c.* 1810 and were demolished in 1975, are just left of centre. To their right is the south end of the terrace on the west side of Montague Place. Originally known as the Seven Houses, this terrace was built *c.* 1780.

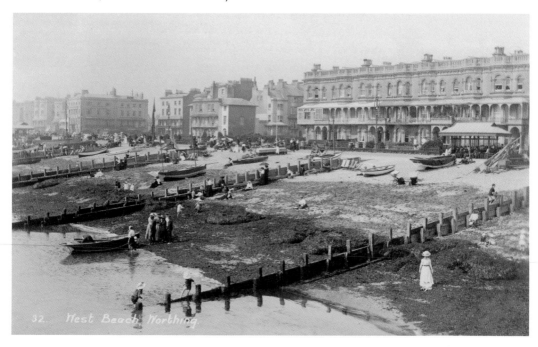

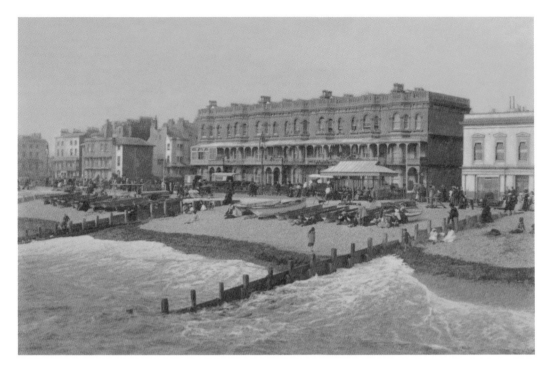

The County Club

The square building at the right of these cards, No. 35 Marine Parade, between Bath Place and the Royal Hotel, was originally the New Parisian Baths, built in 1829 on the site of Wicks' Marine Baths of 1797. The New Parisian Baths closed in 1837, and later the building was the Pier Bazaar, which closed in 1888, and then briefly the Parade restaurant. From 1891 to 1934 it was a gentlemen's club called the County Club. It was demolished in 1935.

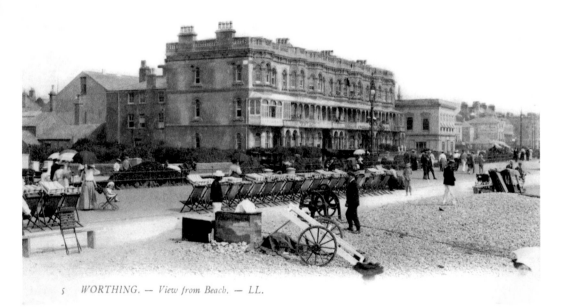

5 WORTHING. — View from Beach. — LL.

43

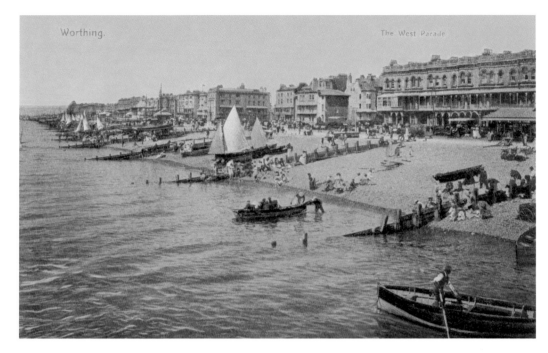

The West Parade

Cambridge Terrace

Cambridge Terrace (Nos 42–36 Marine Parade), prominent on the cards on these two pages, is perhaps the most attractive surviving Victorian terrace on the seafront – and it is a precious survival, not least because it stands to the east of an area that has been devastated during the past seventy-five years. For a distance of 125 yards to the west of Cambridge Terrace not a single seafront building that was present in the Edwardian age remains.

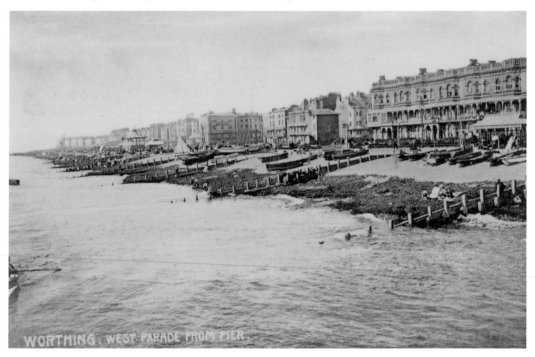

WORTHING. WEST PARADE FROM PIER.

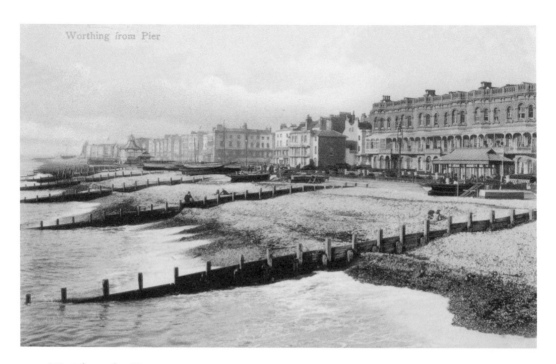

West from the Pier

The cards on this page and the facing page, which show the much-photographed view west from the pier, provide good examples of the diversity of tones chosen by different colourists working on the same scene. The photograph below and the one at the top of p. 44, although published by two different firms – Hartmann and Victoria Series respectively – were clearly taken a few minutes apart on the same day, and by the same photographer.

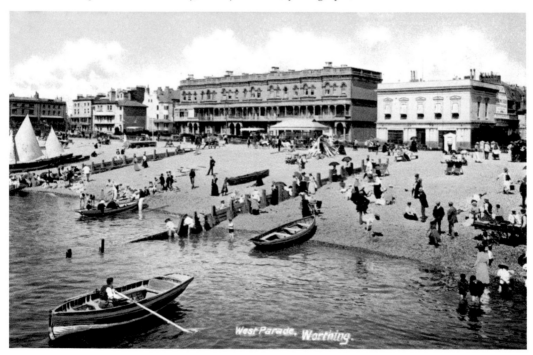

West Parade, Worthing.

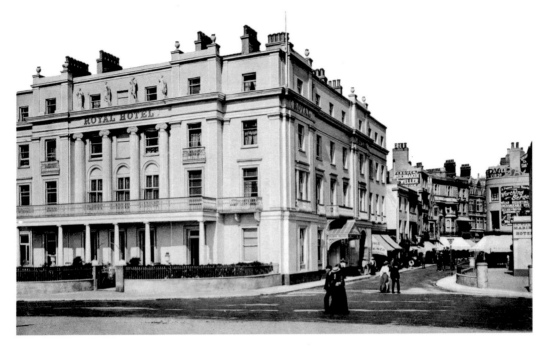

The Royal and the Marine

The Royal Hotel, above, and the Marine Hotel, below, stood on either side of the sea-end of South Street. Both were built during the reign of George IV as replacements for eighteenth-century inns. The Royal, originally called the Sea House Hotel, was Worthing's leading hotel until it burnt down on 21 May 1901. The Marine Hotel was demolished around fifty years ago, to be replaced by the Marine public house, which was itself later demolished.

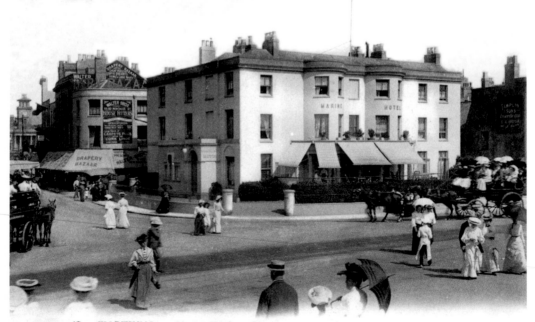

47 WORTHING. — Marine Hotel. — LL.

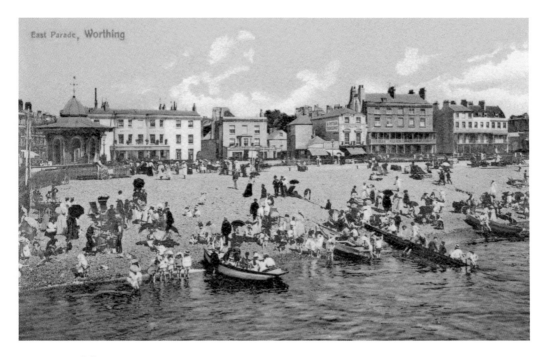

East of the Pier

The buildings in these two similar views of the same stretch of seafront are identified from the card above, left to right: eastern pier kiosk; Marine Hotel; Pier Hotel; Nos 31–30 Marine Parade (a single-storey building shared by a confectioner and an omnibus office); No. 29 Marine Parade (Alfred Puttock's shop); Nos 28–26 Marine Parade (Great Terrace); Nos 25–23 Marine Parade (Little Terrace). The Pier Hotel and Nos 31–30 are gone, but Nos 29–23 survive.

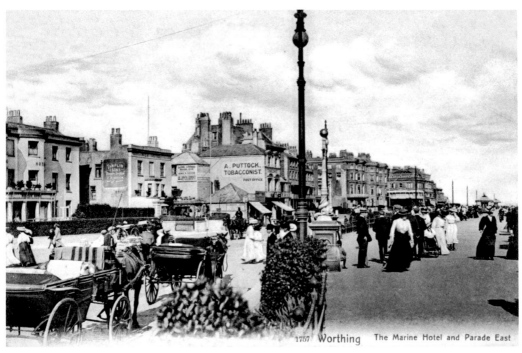

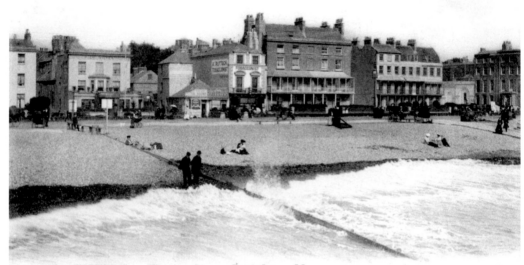

7 *WORTHING.* — *View from Pier.* — *Rough Sea.* — LL.

The Pier Hotel and the Lifeboats

The Pier Hotel, above, second from left, was originally a two-storey house called Marine Cottage and then, from *c.* 1816 to 1863, the Wellington Inn. Restructured in 1938 in art deco style with a fourth storey, it was demolished around fifty years ago. Great Terrace and Little Terrace, to the right of Alfred Puttock's shop, were built *c.* 1785. The card below is Edwardian, but the photograph was taken at a Lifeboat Demonstration held in August 1894.

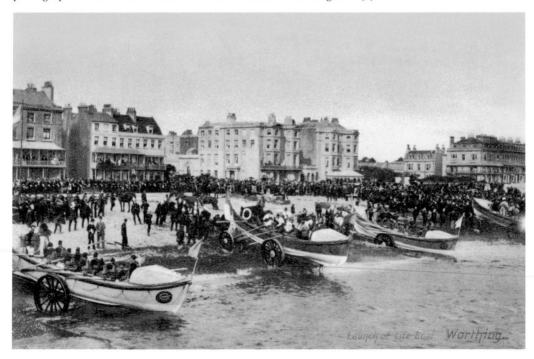

Launch of Life-Boat Worthing.

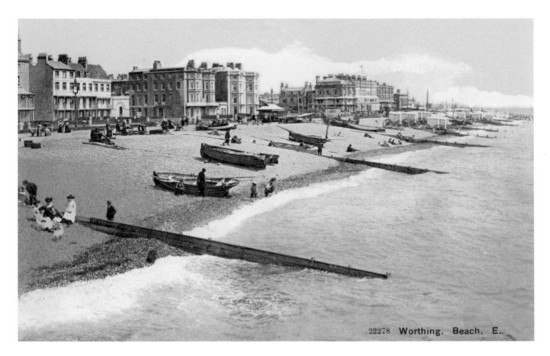

22278 Worthing. Beach. E.

The Clarendon House Boarding Establishment

In the Edwardian era the building at left of centre above (tinted light brown) and at left below was the Clarendon House Boarding Establishment, Nos 20 and 19 Marine Parade, built *c.* 1805 as Stafford's Marine Library and Rebecca House. In 1978 the building was reduced to one storey. The small building to its east, No. 18 Marine Parade, always one-storey, was the Steyne Baths from 1886 to 1903, and then became Worthing Sailing Club. It still stands today.

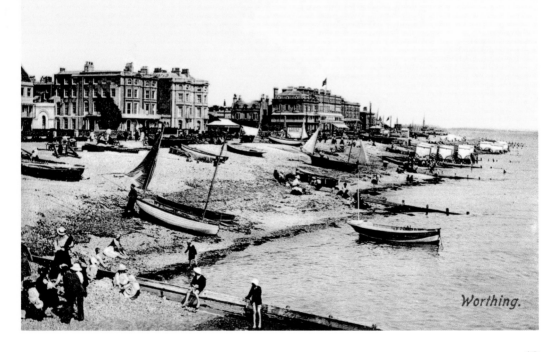

Worthing.

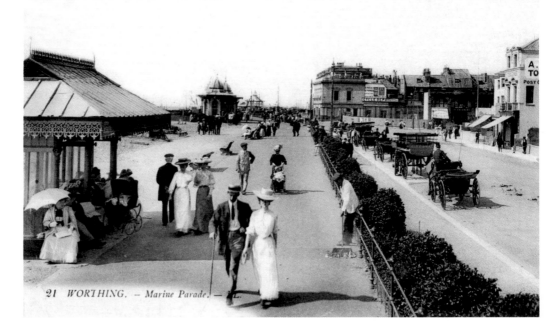

21 WORTHING. — Marine Parade. — LL.

Looking West Towards the Pier

These two Lévy cards looking west towards the pier kiosks and the County Club share the same number but were taken a few minutes apart. The horse-drawn cabs on the right of the two pictures are arrayed identically in both pictures, and some of the figures appear in both, including the woman with the white parasol seated at far left. Visible beyond the line of cabs is the hoarding around the site of the Royal Hotel, burnt down in May 1901.

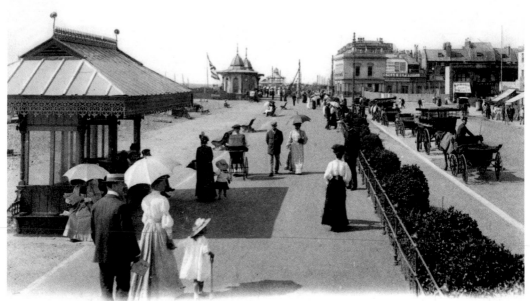

21 WORTHING. -- Marine Parade. — LL.

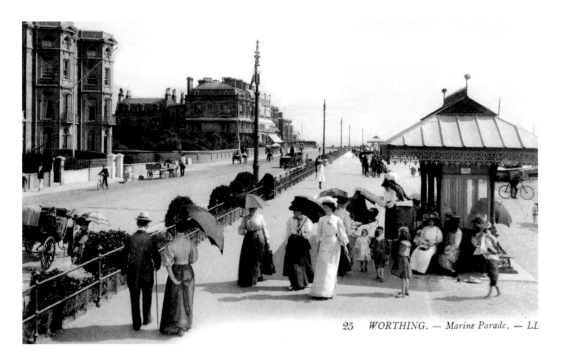

25 *WORTHING. — Marine Parade. — LL*

Looking East Towards Steyne House

These two Lévy views also share a number. They look east from the other side of the shelter that appears in the cards on p. 50. On the left is the Steyne Hotel, followed by Steyne Gardens and Steyne House. The cart on the left, the cab in the centre, and the man and bicycle on the right appear in both pictures, while the girl seated at the right in the card above has had to move up to accommodate a woman who has arrived with a pram.

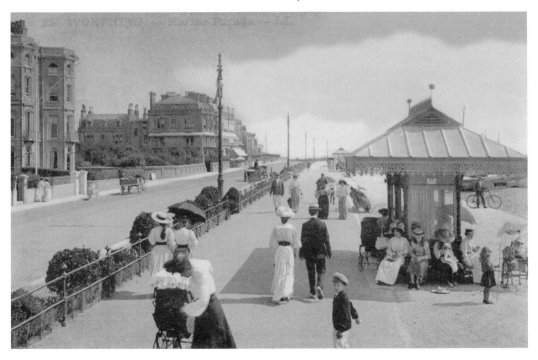

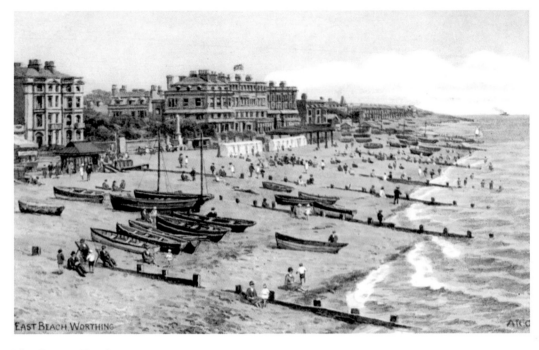

The Steyne Hotel

The A. R. Quinton postcard above dates from *c.* 1930, but this section of the seafront had not changed in the twenty years since Edward VII died. The Steyne Hotel and Steyne Terrace, below, were built in 1807–08 by Edward Ogle, who was the town's leading citizen between 1801 and his death in 1819. Jane Austen, who stayed in Worthing in late 1805, knew Ogle, and based one of the main characters in her unfinished first novel, *Sanditon*, on him.

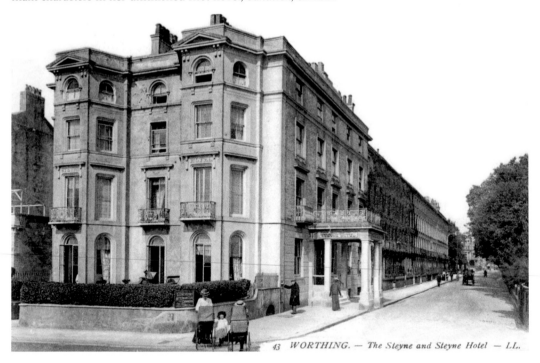

43 *WORTHING. — The Steyne and Steyne Hotel — LL.*

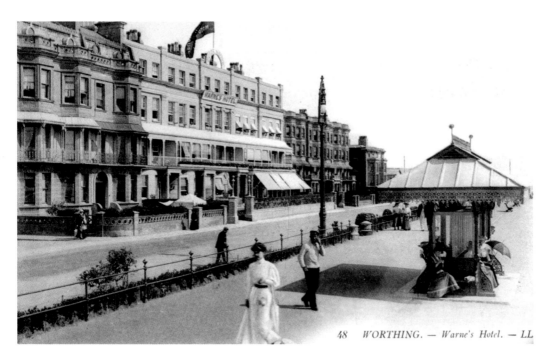

48 *WORTHING. — Warne's Hotel. —* LL

Warne's Hotel

The building on the left of these cards is Steyne House, and at centre-left are Nos 15–11 Marine Parade, built as York Terrace *c.* 1826. Between 1899 and 1909 Warne's Hotel gradually acquired all the houses in York Terrace. As can be seen below, there was a gap between the terrace and Steyne House, which became part of Warne's only in the late 1920s. The hotel closed in 1985, suffered a severe fire in 1987, and was demolished a few years later.

WARNES HOTEL FROM BEACH. WORTHING.

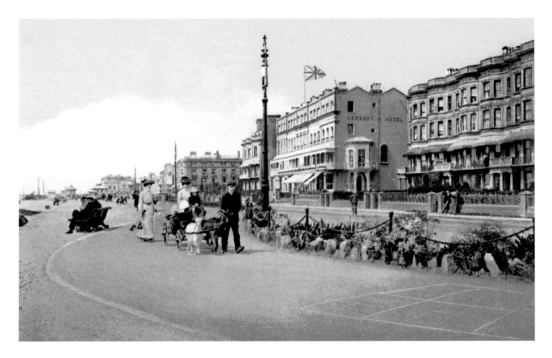

Eardley House

The terrace on the right of these two cards, Nos 10–3 Marine Parade, was built in 1868. Miss Jane Butler opened a boarding-house at No. 3 in 1881, and in 1884 she named it Eardley House. It occupied Nos 5–3 from 1893, and – by then the Eardley Hotel – it acquired Nos 7–6 in 1959 and Nos 10–8 in 1973. The hotel closed in 1988, and the building was demolished in 2008 and replaced in 2012 by a superb new block modelled on the original Victorian terrace.

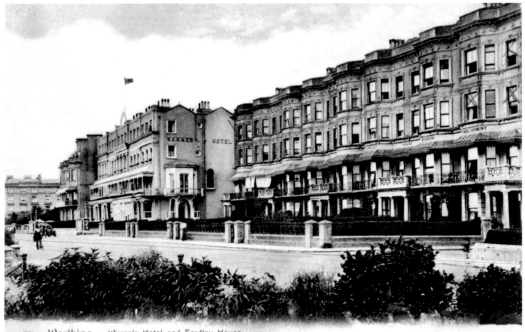

1766 Worthing Warne's Hotel and Eardley House

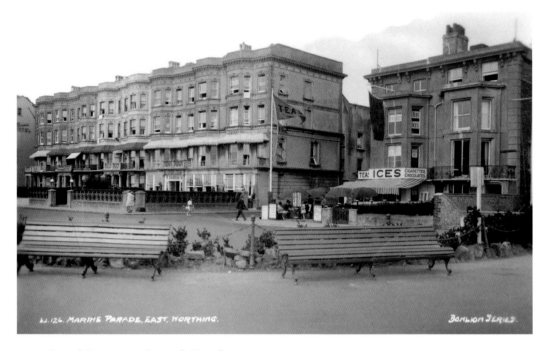

Gravel Terrace and Beach Parade

This postcard, probably from the 1940s, shows Nos 10–1 Marine Parade, with Eardley House still occupying only Nos 5–3. Gravel Terrace, originally Greville Terrace, was the final building with a Marine Parade address (Nos 2–1), although the – unnumbered – boathouse of the Worthing Amateur Boat Club stood just to its east, where the newer boathouse of what is now the Worthing Rowing Club stands today. Below is a view of Beach Parade, looking east from Splash Point.

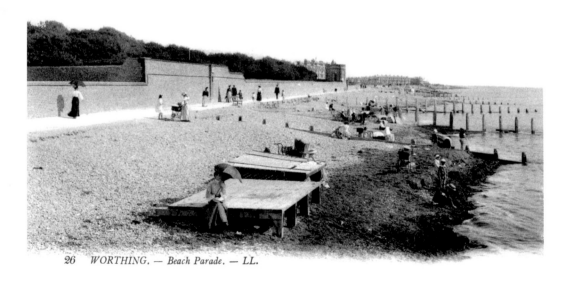

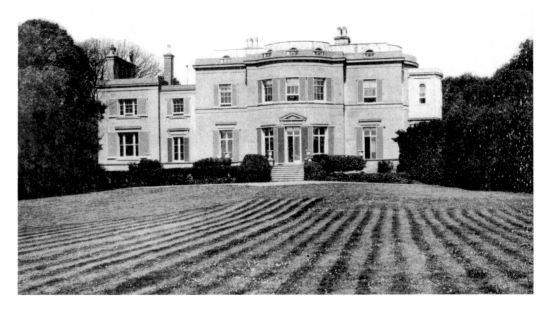

Beach House and Beachfield

Behind the sea-wall to the east of Splash Point, seen in the lower card on p. 55, were the grounds of Beach House, which Edward VII several times enjoyed the use of during the last few years of his reign (see Introduction, p. 7). The owner of Beach House was Sir Edmund Loder, who sold it in 1917 to the playwright Edward Knoblock, who lived there until 1923. To the east of Beach House stood the house known from 1899 as Beachfield, below, also set well back from the sea.

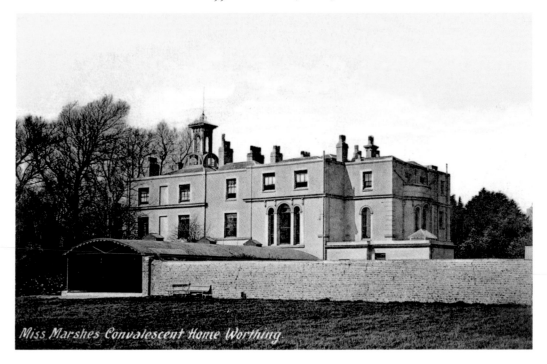

Miss Marshes Convalescent Home Worthing

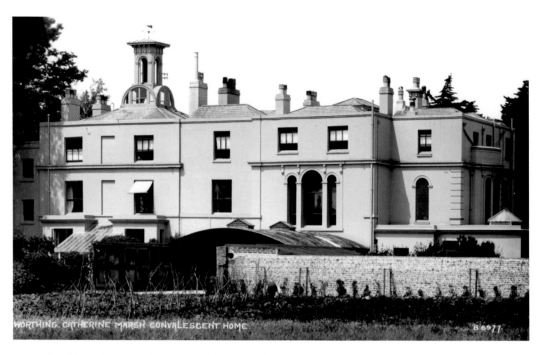

The Convalescent Home and New Parade

Beachfield, above, was occupied from 1901 to 1947 by a convalescent home named after the Victorian philanthropist Catherine Marsh (1818–1912), who visited the establishment several times during its first few years. The house was converted into nine flats *c.* 1947, and was demolished in the late 1950s. (See also p. 86.) Beyond the Catherine Marsh Convalescent Home was New Parade, below, built in 1902–04, which survives.

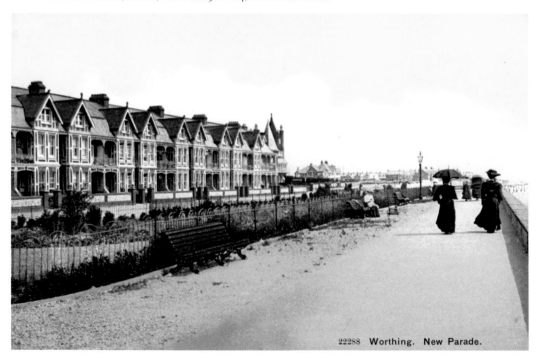

22288 Worthing. New Parade.

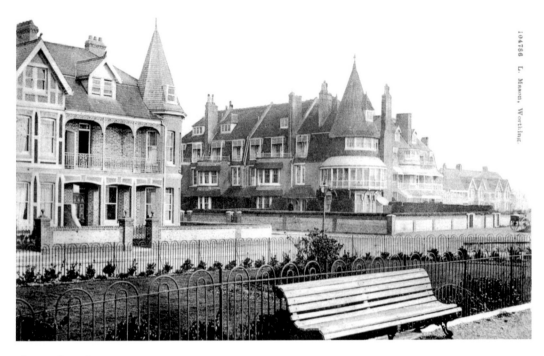

104786 L. Mason, Worthing

The Esplanade

Above is the eastern end of New Parade, followed by the Esplanade, built *c.* 1881 and demolished in the late 1960s. (See also p. 87.) The Esplanade consisted of four terraced houses, Nos 5–8, at centre above and at far left below, the house with the semi-circular balcony being No. 8; and two pairs of semi-detached houses to the east, Nos 4–1, which were allocated Brighton Road addresses *c.* 1920. The terrace ended its days as the Esplanade Hotel.

Marina (East), Worthing

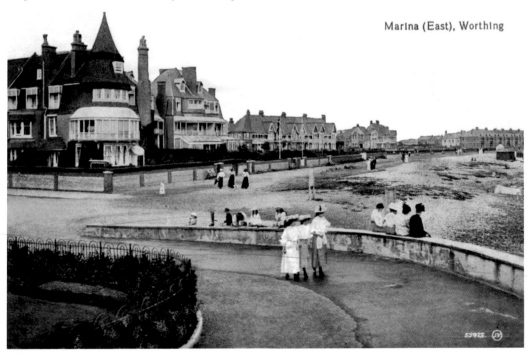

Section 3

BANDSTAND, BEACH AND PIER

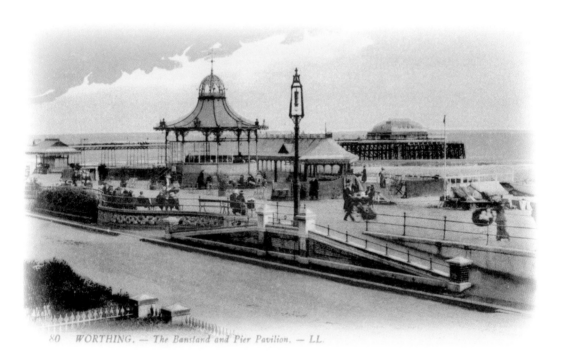

80 WORTHING. — The Bandstand and Pier Pavilion. — LL.

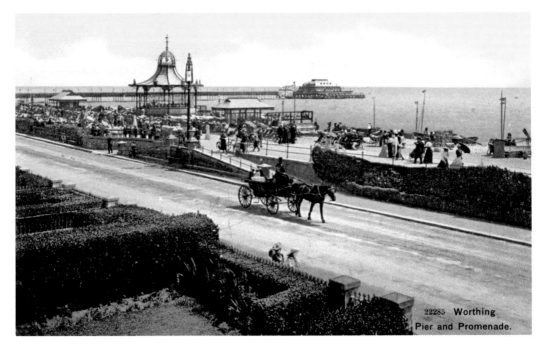

22285 Worthing
Pier and Promenade.

The Birdcage Bandstand

The birdcage bandstand was erected in 1897 in a location that had been served until then by a portable bandstand, which was subsequently used in Steyne Gardens. (See p. 81.) The birdcage bandstand was replaced in 1925–26 with a large band enclosure and a bandstand with a triangular roof. This was itself replaced in 1929 with a round bandstand with a domed roof, which survives today inside what is now the Lido.

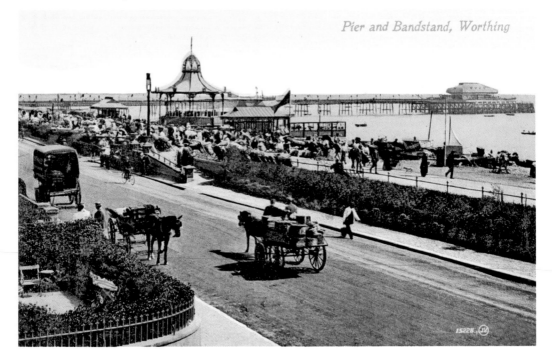

Pier and Bandstand, Worthing

15228.(JV)

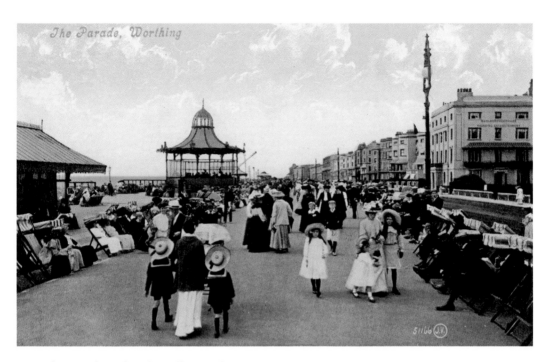

The Parade, Worthing

The Bandstand and Marlborough House

Two views of the bandstand, with Marlborough House on the right. The message on the card below, posted on 29 August 1911 from No. 37 Lanfranc Road, Worthing, reads, 'Dear Brookie, Having a ripping time down here. Plenty of fun. Mollie.' The card was addressed simply to 'Miss G. Brooks, Whiteleys, Queens Rd, Refreshment Dept'. Perhaps Mollie thought that Whiteley's department store in Bayswater was so well-known that this address would be adequate.

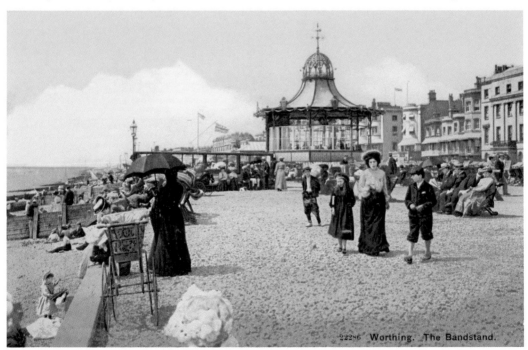

Worthing. The Bandstand.

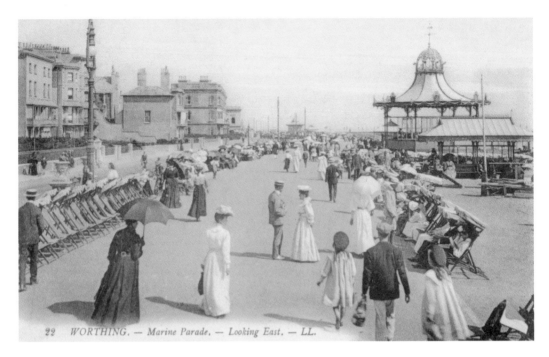

22 WORTHING. — Marine Parade. — Looking East. — LL.

The Bandstand from the West

These four cards from the two publishers most represented in this collection are of particular interest because the cards in each pair are of an almost identical view. The Lévy scenes – above and opposite below – were photographed in 1906, while the Harold Camburn cards date from *c.* 1910. The message on the card below reads, 'Just been in and had a pint and now we are going to have a quart. It is a lovely day down here. Ena.'

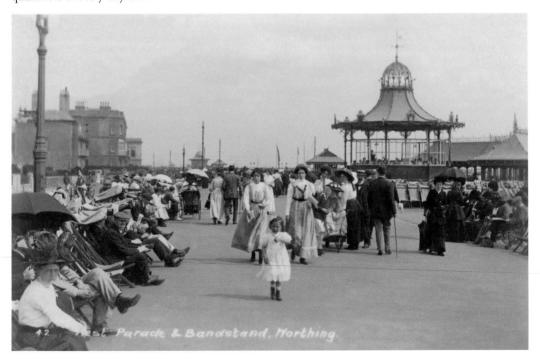

42 West Parade & Bandstand, Worthing.

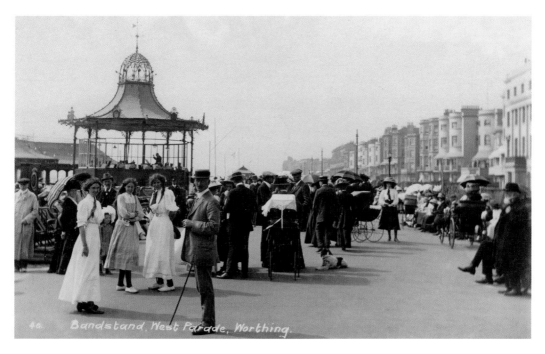

Bandstand, West Parade, Worthing.

The Bandstand Shelter

The shelter to the south of the bandstand was erected in 1907, hence its presence on the Camburn cards but not on the Lévy cards of 1906. Harold Camburn's approach to postcard photography was undoubtedly influenced by the Lévy style and, as noted in the introduction to this book, Camburn also adopted from the Lévy firm the helpful principle of using a separate number-sequence for each location that he photographed.

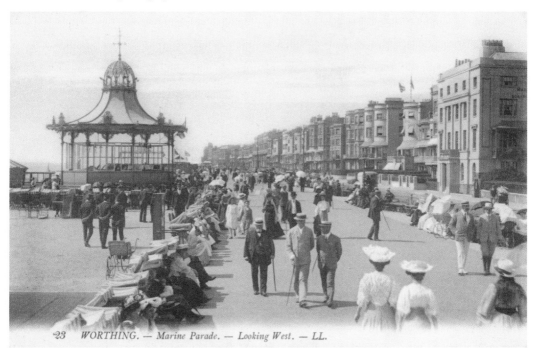

23 WORTHING. — Marine Parade. — Looking West. — LL.

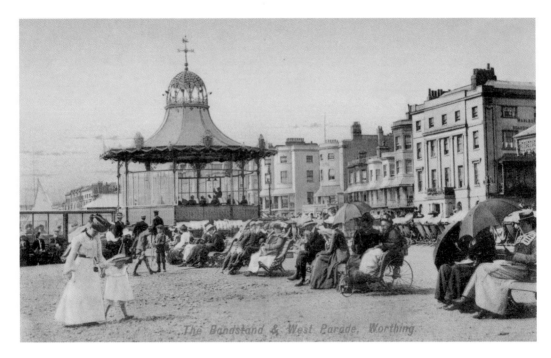

The Bandstand from the East

The message on the card above, posted on 1 August 1905, simply reads, 'I have forgotten your address. Thought you would like a Worthing P. P. C. Much love.' It was addressed to Miss Rowell at Ivy House, Haddenham, Thame, and forwarded to her at No. 15 Westbrook Road, Margate. It was quite common on early postcards for figures in the foreground to be slightly blurred, as on the card below, because of the long exposure times needed.

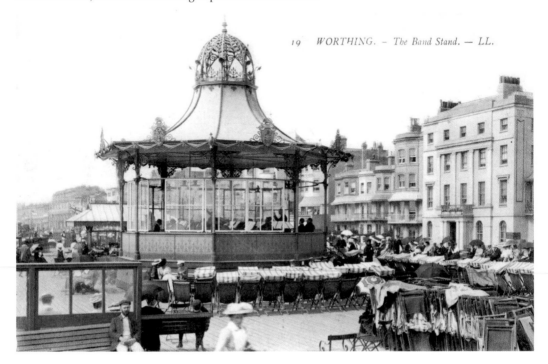

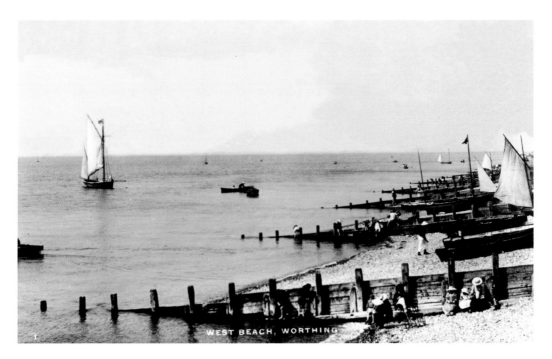

WEST BEACH, WORTHING

Beach and Boats

The postcard above was published by the bookseller and stationer Charles E. Thomas, who had a shop at Nos 11–13 Chapel Road, Worthing. The photographs on the front and back covers of the present book appear in monochrome versions in *The Photographic View Album of Worthing and Neighbourhood*, a large-format book published by Thomas about 1903. The photographs were credited to Valentine & Sons of Dundee, who also printed the book.

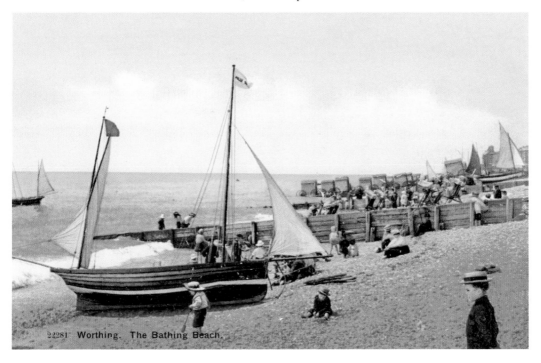

22281 Worthing. The Bathing Beach.

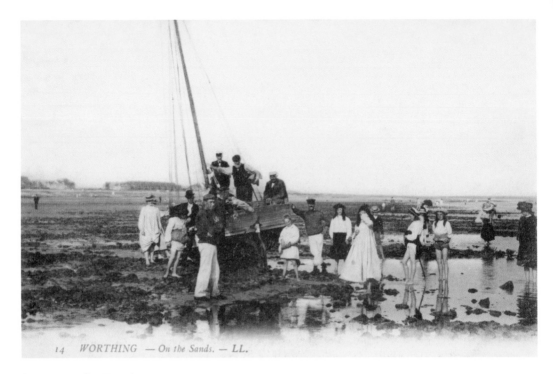

14 *WORTHING — On the Sands. — LL.*

Scenes on the Beach

The card below was sent by Neil Munt to his father, Mr W. G. Munt, at No. 46 West Side, Wandsworth Common, on 28 August 1907: 'The weather here is very hot and I am enjoying myself. The box kite went up lovely. I shall be ready to meet you at 9.30 on Friday evening. The regatta takes places this evening.' It would appear that Neil's father was still at work in London, but was due to join his family in Worthing at the weekend.

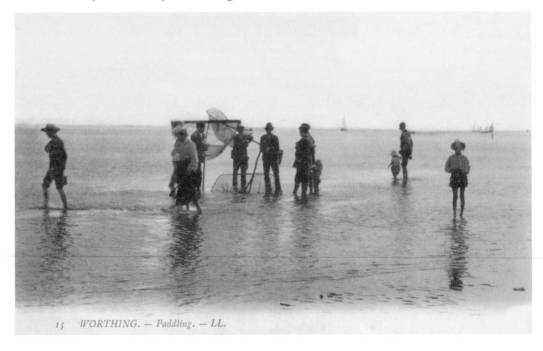

15 *WORTHING. — Paddling. — LL.*

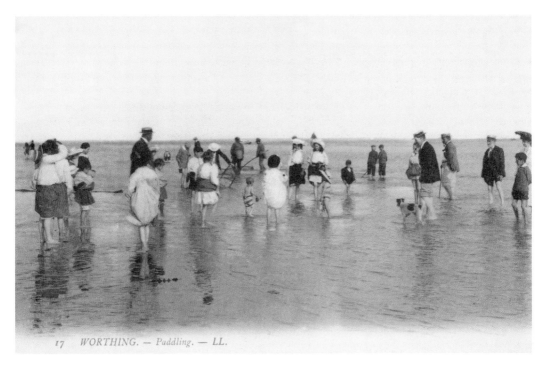

17 WORTHING. — *Paddling.* — LL.

Beach and Bathing Tents

The card above was sent on 4 October 1907 to Bert Ball at No. 38 Lyndhurst Road, Peckham, from Carysfort, a house that used to stand on the north side of Brighton Road between Farncombe Road and Selden Terrace. The sender, who signs with initials only, writes, 'Am having a quiet easy time down here, weather pretty good – only two showers today. There is a young fellow here so I'm not altogether lonely & some people from S. Africa.'

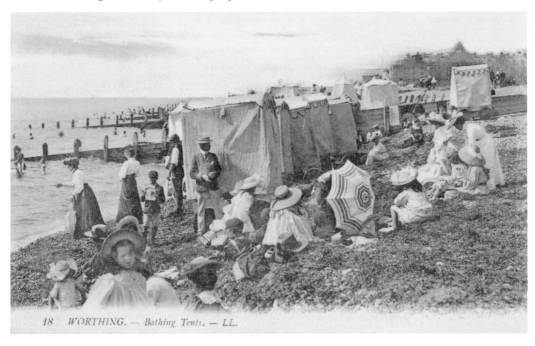

18 WORTHING. — *Bathing Tents.* — LL.

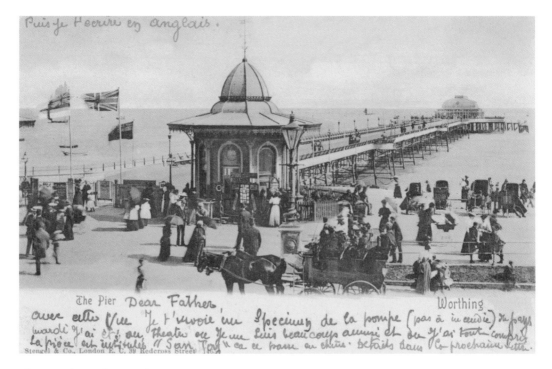

The Pier from the North-West

The card above was sent on 20 August 1903 to the writer's father, Monsieur Biojot, at No. 6 Rue du Cloître, Paris. The child reports that on Tuesday he had been to the theatre – this would have been the New Theatre Royal in Bath Place – to see *San Toy*, a comic opera set in China. He had enjoyed it very much and understood everything. In the postscript at the top of the card, young Biojot assures his father that next time he will write in English.

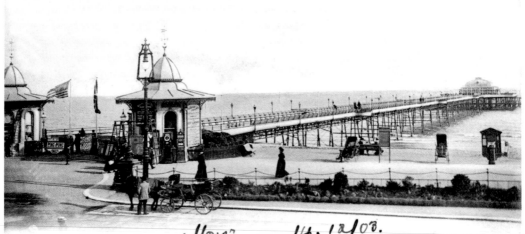

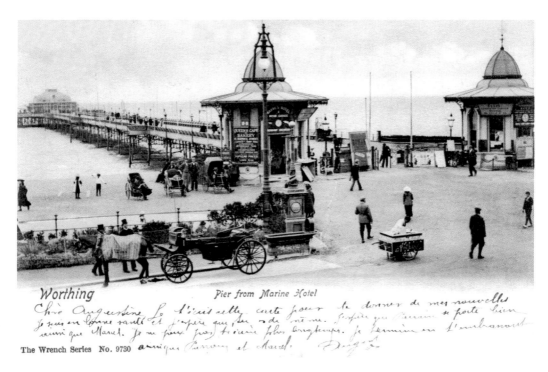

Worthing *Pier from Marine Hotel*

Chère Augustine Je t'écris cette carte pour te donner de mes nouvelles Je suis en bonne santé et j'espère qu'il en est de même. Espère que Fernand se porte bien ainsi que Marcel. Je ne puis pas t'écrire plus longtemps. Je termine en t'embrassant

The Wrench Series No. 9730 *ainsi que Fernand et Marcel.*

The Pier from the Marine Hotel

Worthing pier, which opened in 1862, was originally a simple structure just 16 feet wide, but it was upgraded in 1888–89, the decking being doubled in width and a pavilion being added at the sea-end for music and entertainments. These two versions of the same photograph are a good example of what was gained and what was lost when a view was tinted. Although the colours are rich and attractive, the detail is much less clear.

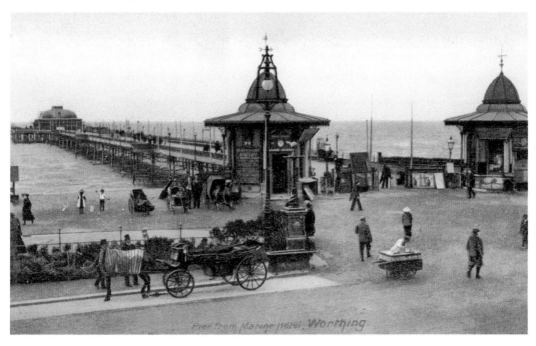

Pier from Marine hotel. Worthing.

13 *WORTHING. — The Beach and Pier. — LL.*

Sailing Boat and South Pavilion

The pavilion at the sea-end of the pier was destroyed by fire in 1933. It was inside this pavilion on 13 September 1894 that Oscar Wilde presented the prizes for the best-dressed boats at the end of a lamp-lit Venetian Fête, and made a well-received speech. He described Worthing as a charming town, and said that it had beautiful surroundings and lovely long walks, which he recommended to other people, but did not take himself.

22293 Worthing. The „Britannia".

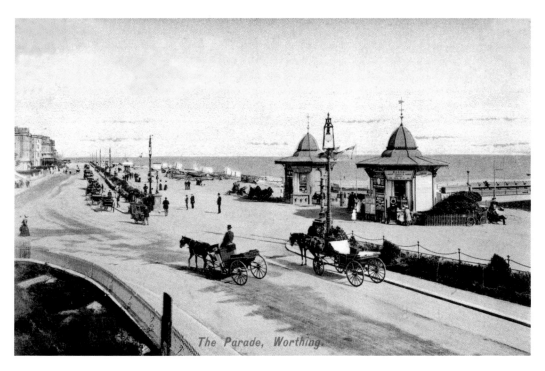

Around the Pier Kiosks

These two not very high-quality tinted cards are of interest because they show how open and spacious the area around the pier kiosks was in Edwardian times. The card above, posted on 18 January 1905, was addressed to Master Funnell at No. 22 High Street, Newhaven. The message reads, 'Another card for your album, dear. I hope you are quite well. Love and x from Mama.' In those days even children were keen postcard collectors.

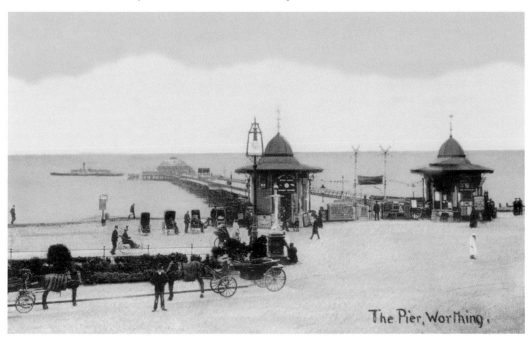

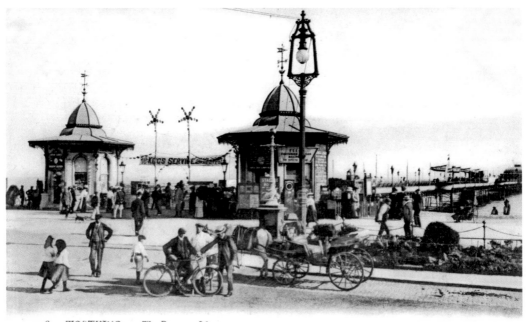

8 WORTHING. — The Pier. — LL.

The Pier Kiosks

The pier kiosks were built in 1884 and survived until 1925–26, when they were replaced with the current pier pavilion. Newspapers were sold at the left-hand kiosk, while the main purpose of the right-hand kiosk was the sale of tickets for the pier, access to which was not free in those days. Most of the advertisements are the same as on the card on p. 69, the left-hand kiosk advertising Warne's Hotel and the right-hand kiosk the Stanhoe Hotel.

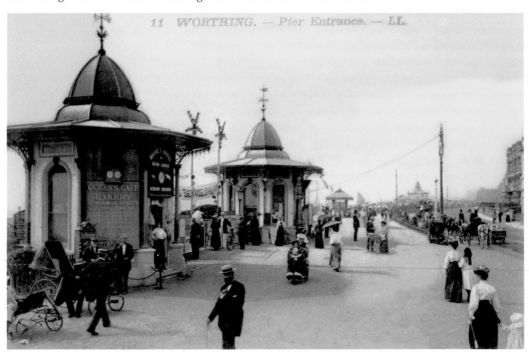

11 WORTHING. — Pier Entrance. — LL.

SECTION 4

THROUGH THE TOWN

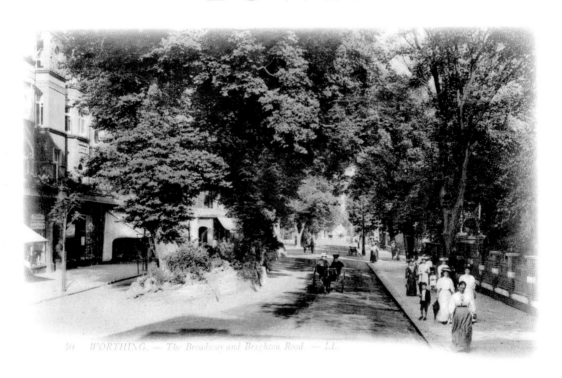

40 WORTHING. — The Broadway and Brighton Road — L.L.

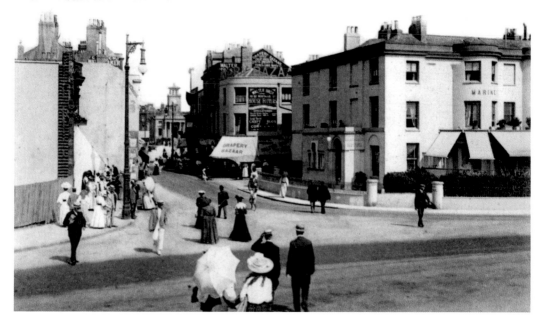

South Street

This was the scene that confronted an Edwardian visitor setting off up South Street towards the town centre. On the right is the Marine Hotel, and on the left the site of the Royal Hotel, on which nothing was built between the hotel's destruction by fire in May 1901 and the construction of the Arcade in 1925. At the north end of South Street stood the old Town Hall, built in 1834–35 on land bought from Sir Timothy Shelley, father of the poet.

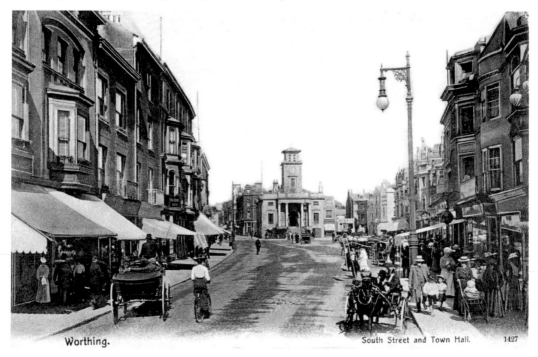

Worthing. South Street and Town Hall. 1427

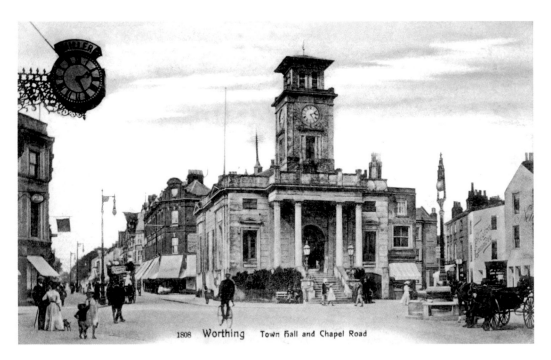

1808 Worthing Town Hall and Chapel Road

The Old Town Hall

The old Town Hall was superseded in 1933 by a new building in Chapel Road, and in 1950 the clock tower was adjudged to be unsafe and removed. By the 1960s the interior had fallen into disrepair, and the rest of the Town Hall was demolished in 1968, a prelude to the wholesale redevelopment of the heart of nineteenth-century Worthing that also accounted for Market Street, the north side of Ann Street and part of High Street.

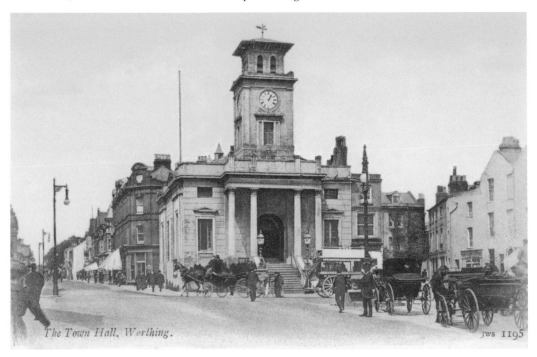

The Town Hall, Worthing. JWS 1195

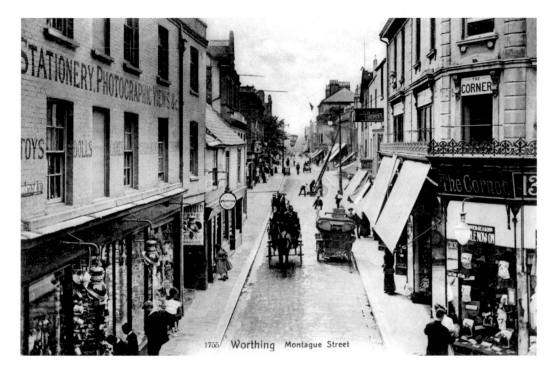

Montague Street

These two postcards show the eastern end of Montague Street. The view above is west-facing, and the view below east-facing. Montague Street was the location of two of Worthing's first cinemas, the Winter Hall and St James's Hall, which began showing films in 1906 and 1908 respectively. The sign on the front of St James's Hall can be seen on the left of the postcard below, although the building itself is almost entirely hidden.

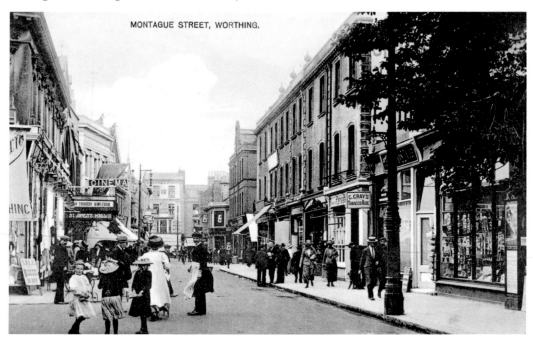

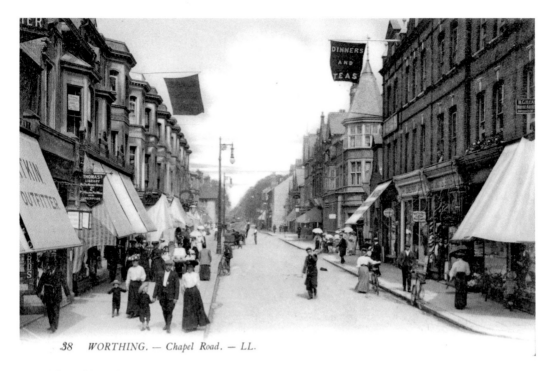

38 WORTHING. — *Chapel Road*. — LL.

Chapel Road

Chapel Road, named after the Chapel of Ease (1812, later St Paul's church), was completed in 1815, becoming the main road into the centre of Worthing from the north. Above is the southern end of the street, with the entrance to Market Street at centre-right, and below is the section just north of the junction with North Street. The house on the right is Worthing Lodge, replaced in 1924 by the Rivoli Cinema, which closed after a fire in 1960.

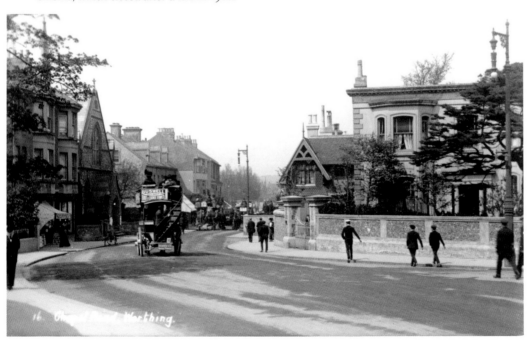

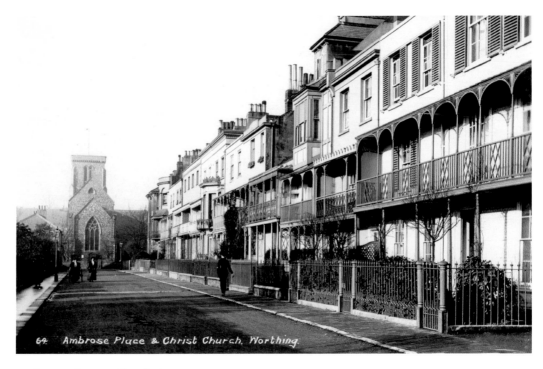

64 *Ambrose Place & Christ Church, Worthing*

Ambrose Place and Park Crescent

The most attractive street leading west off Chapel Road was – and is – Ambrose Place, above, built it in 1814–26 and named after its builder, Ambrose Cartwright. The next street leading west off Chapel Road is Richmond Road, 600 yards along which is the archway that leads to Park Crescent, below, built in 1830–33. Once a fashionable terrace, Park Crescent was part of a larger scheme that was never completed.

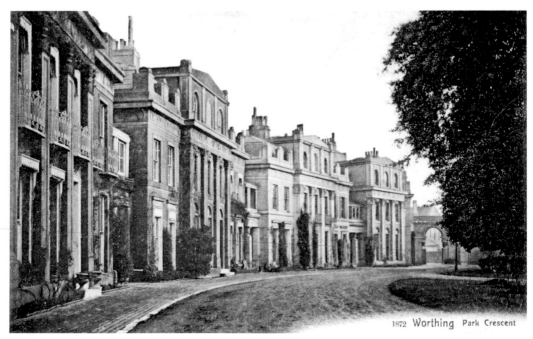

1872 Worthing Park Crescent

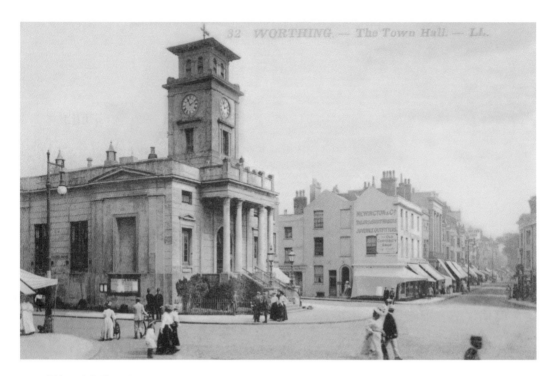

Warwick Street

These two cards show us the view eastward along Warwick Street, which in the Edwardian era still served as part of the main west-to-east road though central Worthing. The shops on the right of the picture below still stand, but of the first three on the left only the narrow building in the middle survives. On the right is the drinking fountain that used to stand in the middle of South Street. The trees formerly in the Broadway can be seen in the distance.

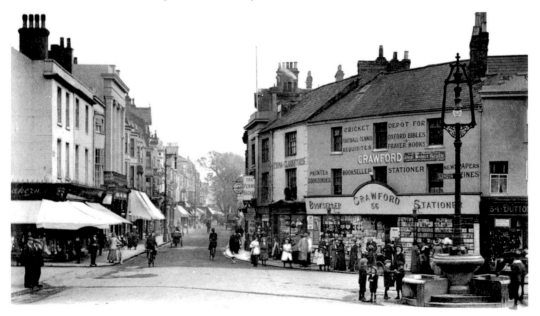

79 WORTHING. — Warwick Street — LL.

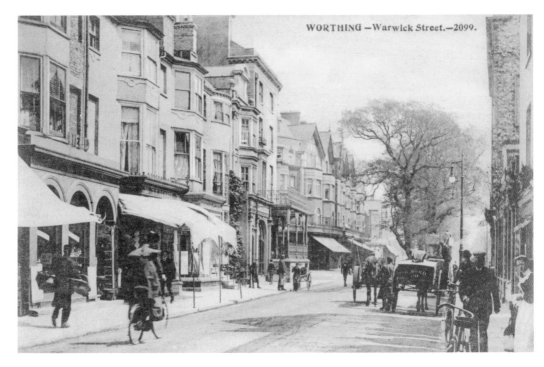

Warwick Street and High Street

The view above is of the eastern end of Warwick Street. Originally largely residential, the street consisted by this time mainly of shops, but two remaining houses can be seen just left of centre. The card below shows High Street, looking north, with Colonnade House on the left. Built by Edward Ogle, c. 1802, it suffered a serious fire in 1888, but still stands today, although much altered. The iron colonnade was removed in the twentieth century.

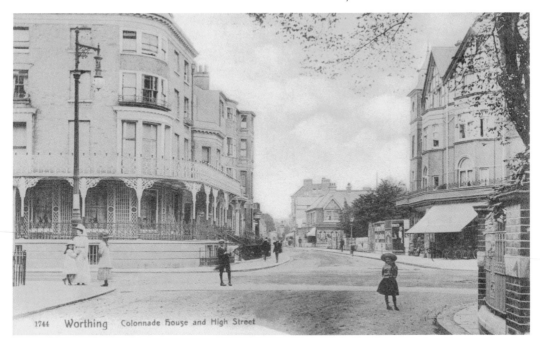

1744 Worthing Colonnade House and High Street

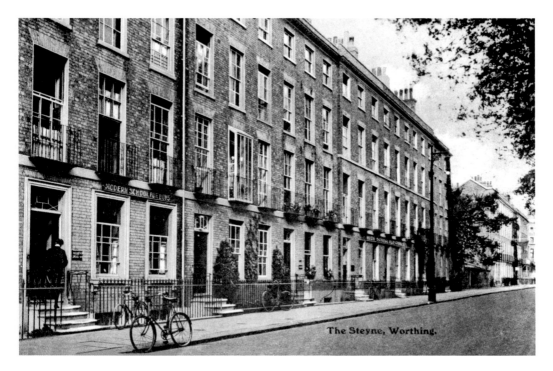

The Steyne, Worthing.

The Steyne Terrace and Steyne Gardens

The view above is of the Steyne Terrace, looking north, with a boys' and a girls' school a few doors apart. The word Steyne comes from Old English *stoene*, meaning a stony place. In 1900 Lady Loder of Beach House, mother of Sir Edmund Loder (see Introduction, p. 7), purchased Steyne Gardens, below, which she refurbished and donated to the town. The portable bandstand had been in use on the seafront until replaced by the birdcage bandstand in 1897.

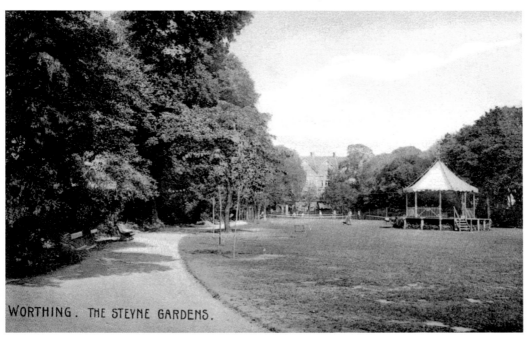

WORTHING. THE STEYNE GARDENS.

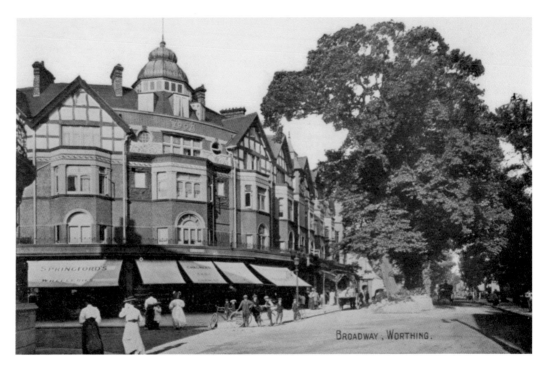

Broadway, Worthing.

Trees in the Broadway

When Warwick House, the historic house that had stood opposite Steyne Gardens since *c.* 1785, was demolished in 1896, the opportunity was taken to widen the section of Brighton Road between Warwick Street and Warwick Place, which was renamed the Broadway. The trees at the front of the former garden of Warwick House were retained, and a new carriageway was created on their north side. The trees were cut down in 1928.

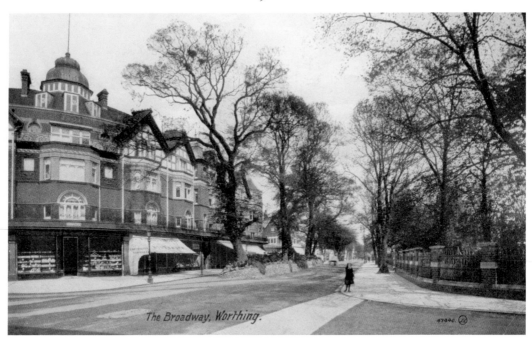

The Broadway, Worthing.

47440.

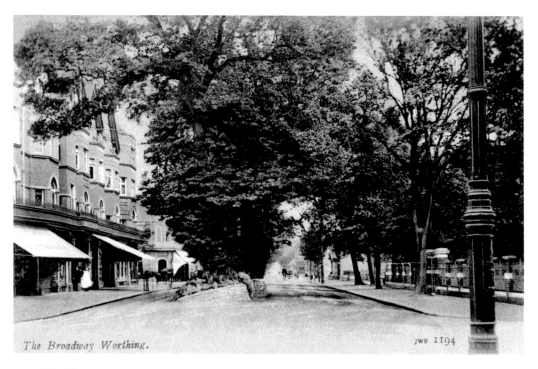

The Broadway Worthing. jws 1194

The Three Mansions

The building erected at the junction of High Street and Brighton Road in 1901 has nine shops at street level. Originally the accommodation above consisted of five three-storey maisonettes. Much sub-dividing has taken place over the years, and the building now has twenty-one flats. Since 1914 the three sections, each served by a separate street entrance, have been known as Warwick Mansions, Broadway Mansions and Kent Mansions.

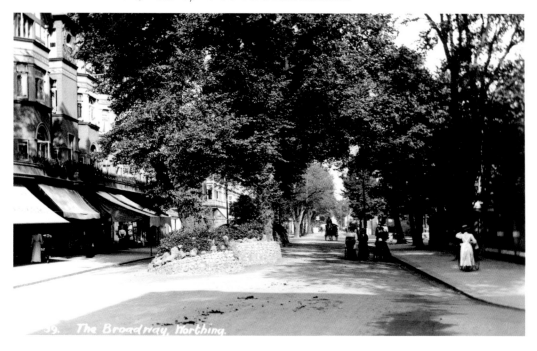

39. The Broadway, Worthing.

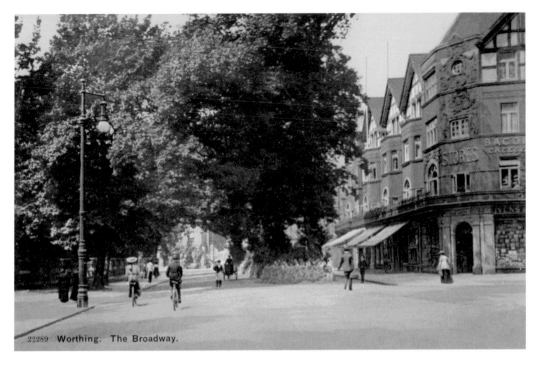

22289 Worthing. The Broadway.

Colour-Tinting the Broadway

With the exception of the seafront, and possibly the old Town Hall, the Broadway appeared on more postcards than any other location in Worthing. Most of the colourists who created colour-tinted cards such as those on these two pages would never have seen the building, hence the wide range of colours chosen for the masonry. Today the block is rendered and painted white, so it is impossible to be sure what the original colours were.

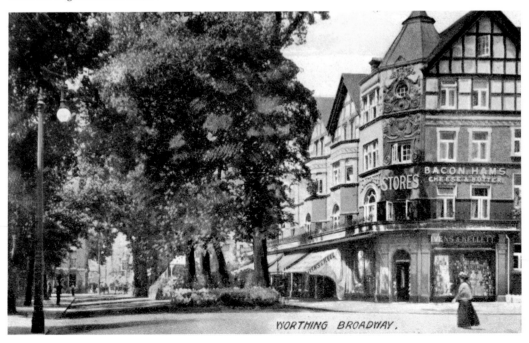

WORTHING BROADWAY.

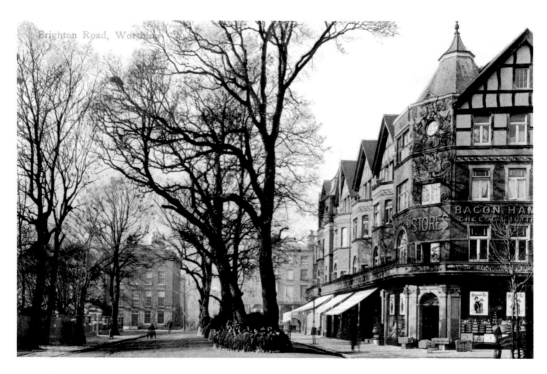

The Kellett Family

From 1901 until around 1950 the shop on the corner, Nos 8–9 The Broadway, was the grocer Ivens & Kellett, whose original partners were Ephraim Kellett, the builder who developed the old Warwick House estate, and Edmund Ivens. Ivens was married to Harriet Kellett, and Tom Kellett was the shop's manager. Amon and Mary Kellett occupied No. 6 The Broadway, initially as a restaurant and temperance hotel and later as a baker and confectioner.

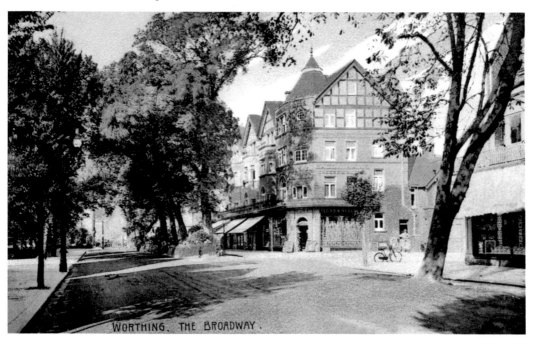

WORTHING. THE BROADWAY.

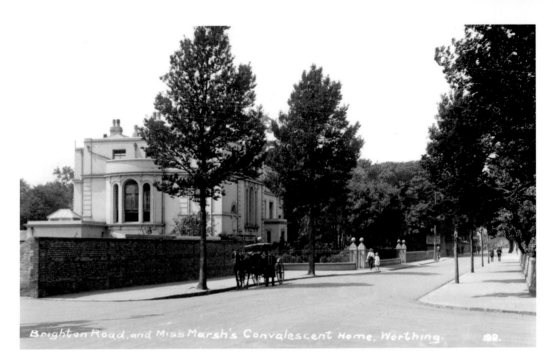

Brighton Road, and Miss Marsh's Convalescent Home, Worthing.

The Catherine Marsh Convalescent Home

This house, which from 1901 until 1947 was the Catherine Marsh Convalescent Home, stood on the south side of Brighton Road, centrally located between the southern ends of Madeira Avenue and Farncombe Road. Originally a small cottage, it was enlarged early in the nineteenth century, and for most of that century was a boys' school under various names, latterly Worthing College. From 1899 onwards the building was known as Beachfield. (See also p. 57.)

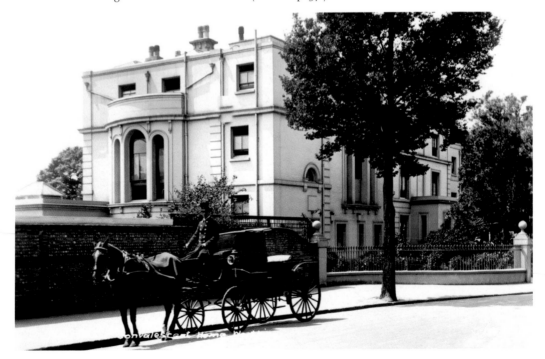

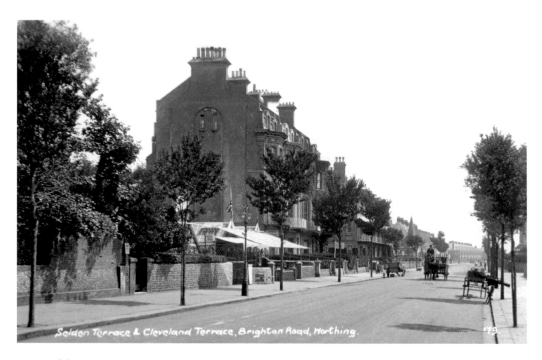

Selden Terrace & Cleveland Terrace, Brighton Road, Worthing.

Selden Terrace and the Esplanade

Of the two Victorian terraces above, Selden Terrace, at centre-left, no longer stands, but Cleveland Terrace, right of centre, survives, to the east of Selden Road. The terraces in the distance were built during the Edwardian era. The house on the right of the card below, between the two tall chimneys, was The Haven, No. 5 The Esplanade. (See also p. 58.) This was where Oscar Wilde stayed with his family in 1894 and wrote his most famous play, *The Importance of Being Earnest*.

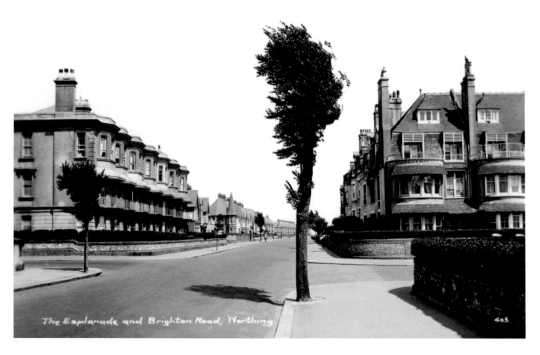

The Esplanade and Brighton Road, Worthing.

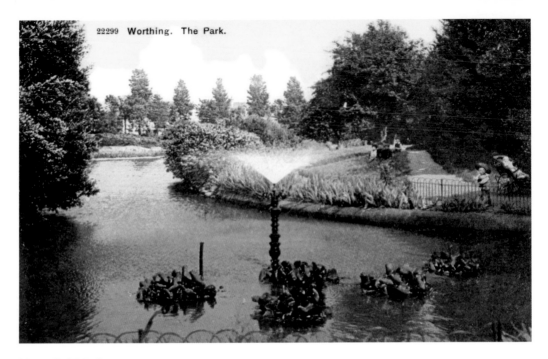

22299 Worthing. The Park.

Homefield Park

Originally known as the People's Park, Homefield Park, laid out in 1880, was Worthing's first municipal park. In the Edwardian era the park consisted of over 14 acres, but the expansion of Worthing Hospital later reduced its size. The lake was at the eastern end of the park, just west of Homefield Road. (See map on p. 91.) The view above is from the south-west corner of the lake, while the view below is from the north bank, looking east.

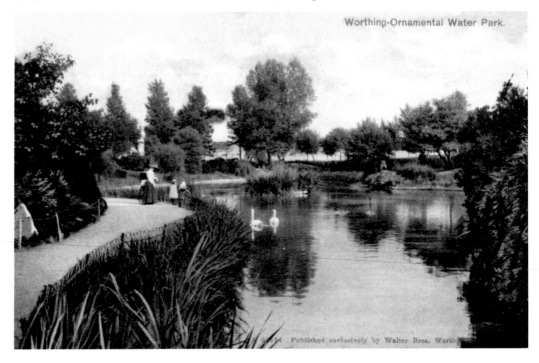

Worthing-Ornamental Water Park.

Published exclusively by Walter Bros. Worthing

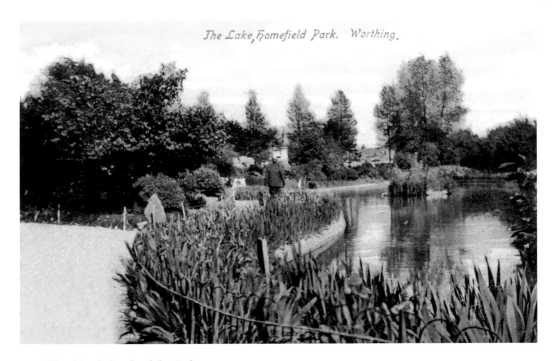

The Lake, Homefield Park. Worthing.

The North Bank of the Lake

These views are of the eastern end of the lake. The rustic bridge can be seen at the centre of the second card. The lake had been formed by damming the Teville Stream, which rises in Tarring and, culverted for most of its length, flows alongside Tarring Road and Teville Road, then joins the Broadwater Brook and flows south to Brooklands Lake and the sea. Teville Road was once known as Vapours Lane on account of the mists generated by the stream.

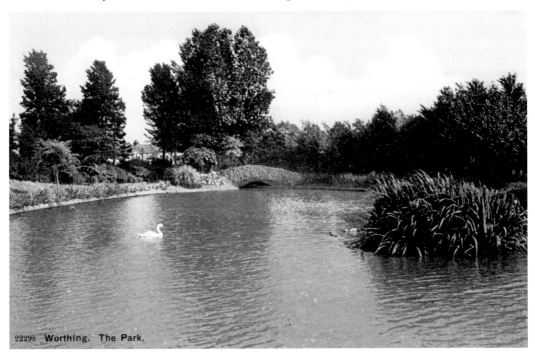

22298 Worthing. The Park.

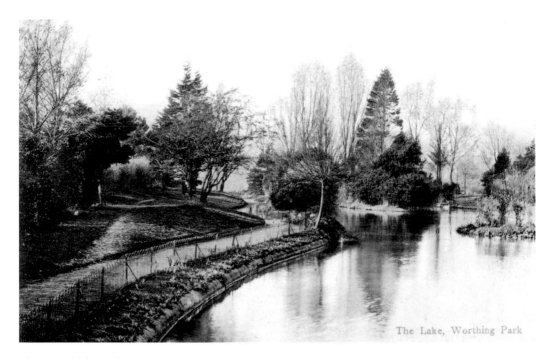

The Lake, Worthing Park

The End of the Lake

These views are of the western end of the lake. The lake was filled in the early 1930s. According to Jack Watts in *Old Worthing As I Remember It, 1906–1920*, this was because the Teville Stream was piped out to Ham Bridge when Chesswood Road was developed, leaving the lake without a water supply. The site of the lake is now a grassy area just north of the eastern end of Park Avenue. The writer ends by assuring his friend in Paris that he is in good health.

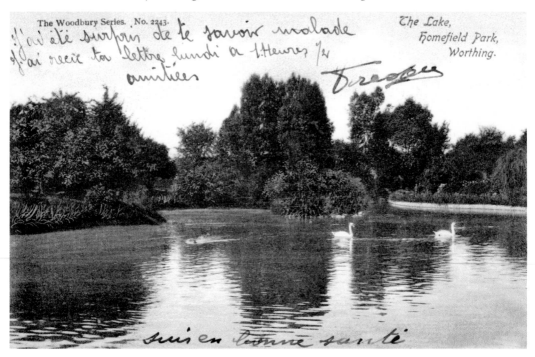

The Woodbury Series. No. 2243.

The Lake,
Homefield Park,
Worthing.

SECTION 5

MAPS OF
WORTHING

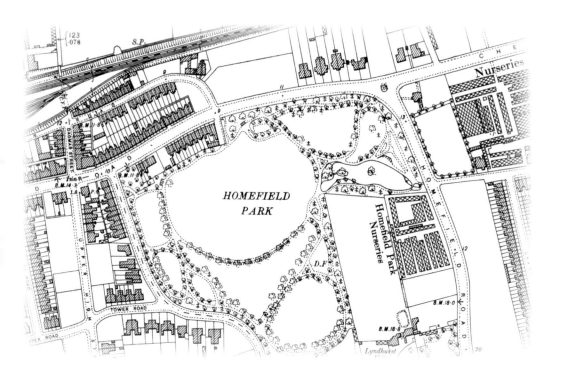

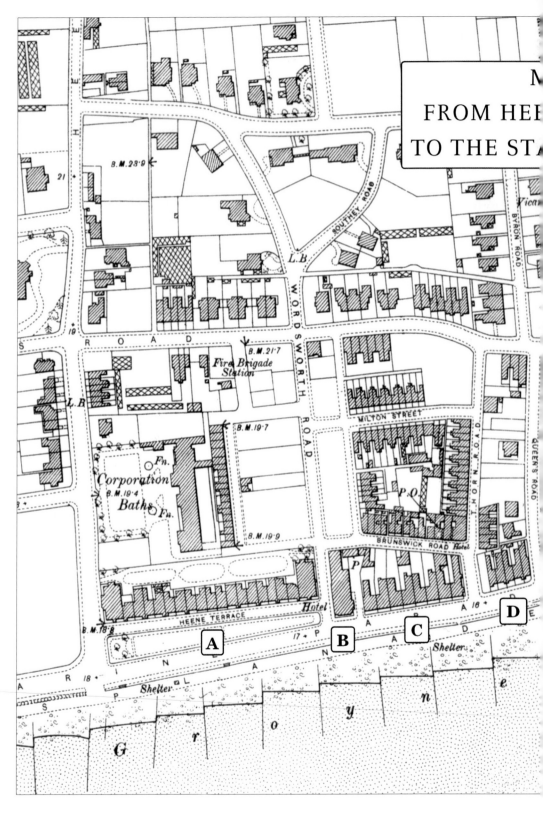

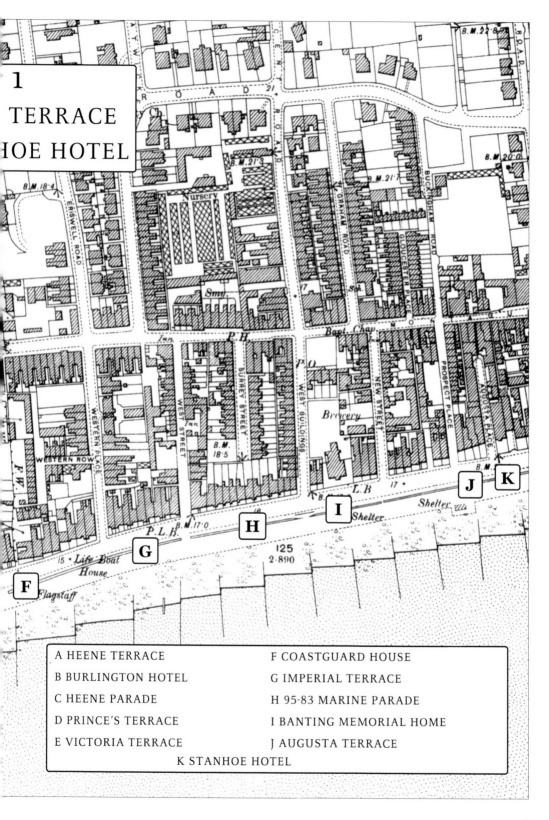

1
TERRACE
HOE HOTEL

A HEENE TERRACE
B BURLINGTON HOTEL
C HEENE PARADE
D PRINCE'S TERRACE
E VICTORIA TERRACE

F COASTGUARD HOUSE
G IMPERIAL TERRACE
H 95-83 MARINE PARADE
I BANTING MEMORIAL HOME
J AUGUSTA TERRACE

K STANHOE HOTEL

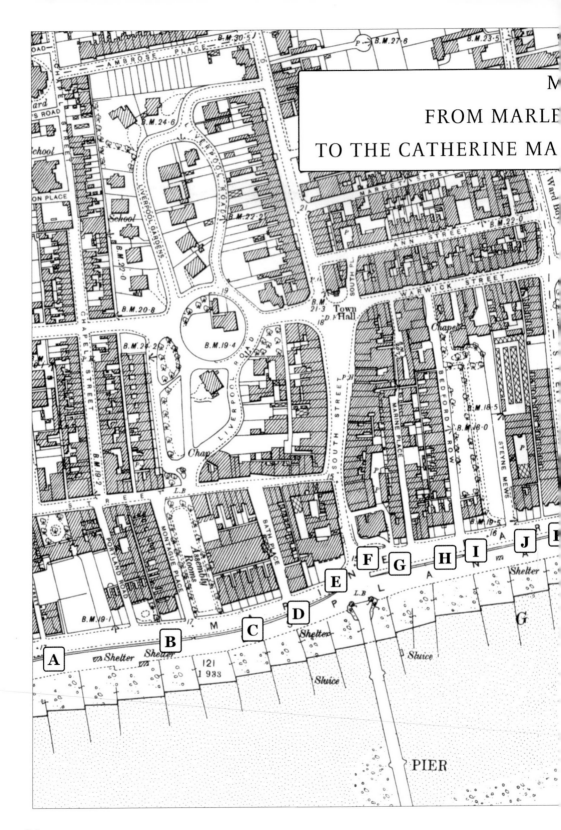

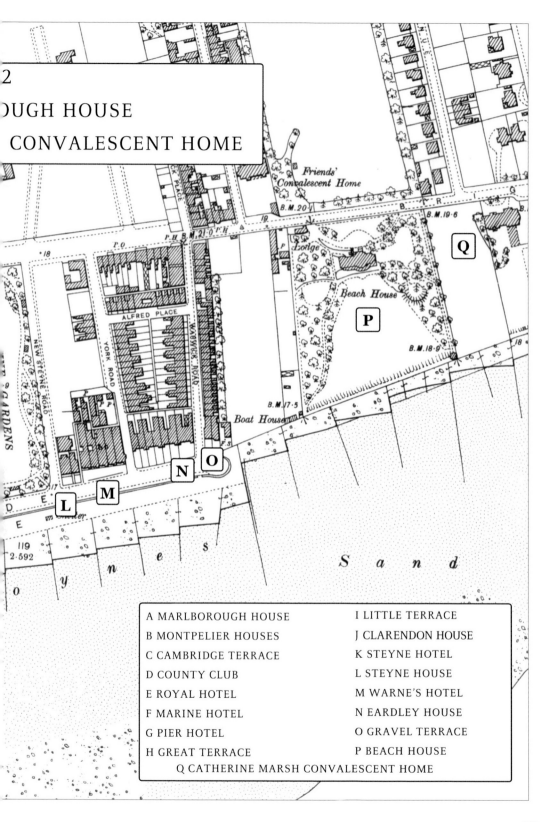

UGH HOUSE

CONVALESCENT HOME

Friends' Convalescent Home

Lodge

Q

Beach House

P

N O

M

L

A MARLBOROUGH HOUSE

B MONTPELIER HOUSES

C CAMBRIDGE TERRACE

D COUNTY CLUB

E ROYAL HOTEL

F MARINE HOTEL

G PIER HOTEL

H GREAT TERRACE

I LITTLE TERRACE

J CLARENDON HOUSE

K STEYNE HOTEL

L STEYNE HOUSE

M WARNE'S HOTEL

N EARDLEY HOUSE

O GRAVEL TERRACE

P BEACH HOUSE

Q CATHERINE MARSH CONVALESCENT HOME

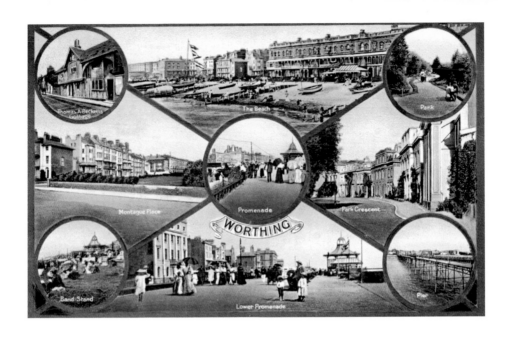

SOURCES & ACKNOWLEDGEMENTS

The main research for this book involved the study of old directories on microfiche at Worthing Library and the exploration of Worthing on foot. Robert Elleray's *A Worthing Millenium Encyclopedia* (1997) was an indispensable resource, and Henfrey Smail's *Gimpses of Old Worthing* (1945) and *The Worthing Map Story* (1949) provided a number of useful facts. Most of the material about Edward VII's visits to Worthing comes from Charles William Stamper's *King Edward as I Knew Him: Reminiscences of Five Years Personal Attendance Upon His Late Majesty King Edward the Seventh* (1913). Two excellent previous books focusing on postcards of Worthing, Rob Blann's *Worthing in Old Picture Postcards* (1993) and Geoffrey Godden's *Collecting Picture Postcards* (1996), should be given honourable mention, although duplication has been largely avoided. Martin Hayes and his colleagues at Worthing Library provided their usual friendly and efficient assistance. Finally, Joanna Nortcliff helped in numerous ways during the preparation of this book, not least in accompanying the author along Worthing seafront to help piece together the then and the now of Marine Parade.

THE AUTHOR

Antony Edmonds was born in Southsea and educated at Churcher's College, Petersfield, and Magdalen College, Oxford. A researcher and writer with a particular interest in the history of Worthing, he has published a number of articles about Jane Austen's and Oscar Wilde's stays in the town. He has contributed regularly to *Sussex Life*, and writes a monthly piece for the *Worthing Herald* about historic buildings of Worthing. This is his first book.